"BOOKSHELF"
Acrylic

This painting is a close-up of a very large bookcase in my friend Mary Boulton's living room. I chose only one shelf to paint because it was typical of all of them, each containing an array of interesting books and "stuff" gathered from years of collecting. It was fun painting and I'm glad I limited myself. One challenge indoor painting offers is learning to be selective. Showing the whole bookcase in this painting would not have brought that much more to the picture. I intentionally chose a long horizontal canvas to go with the subject.

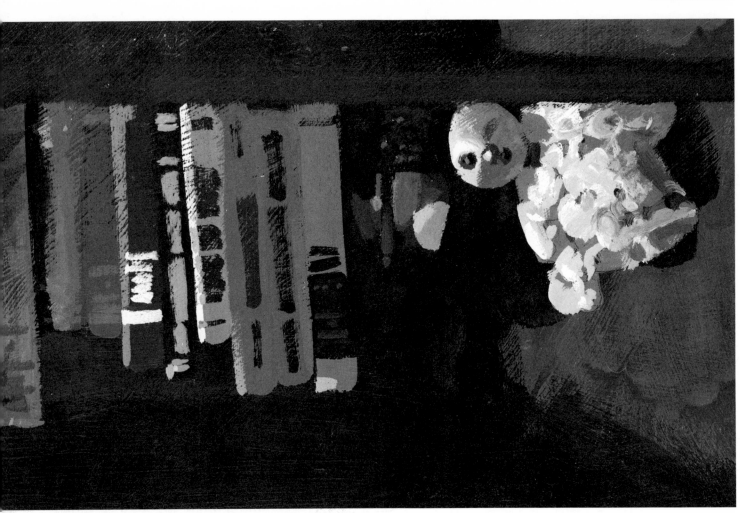

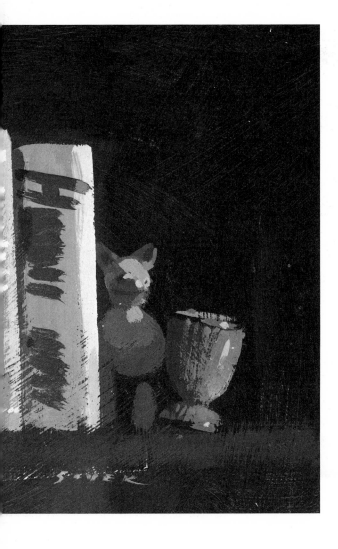

PAINTING INDOORS

by Charles Sovek

North Light Publishers
Westport, Connecticut

Published by NORTH LIGHT PUBLISHERS, a division of FLETCHER ART SERVICES, INC., 37 Franklin Street, Westport, Conn. 06880.

Distributed to the trade by Van Nostrand Reinhold Company, a division of Litton Educational Publishing, Inc., 450 W. 33rd Street, New York, N.Y. 10001.

Manufactured in U.S.A.
First Printing 1980

Library of Congress Cataloging in Publication Data

Sovek, Charles.
 Painting indoors.

 Includes bibliographical references.
 1. Painting—Technique. I. Title.
ND1500.S68 751.4 79-28202
ISBN 0-89134-024-6

Edited by Fritz Henning
Designed by Charles Sovek
Composed in 10 pt Melior
by John W. Shields, Inc.
Printed by Eastern Press
Bound by Economy Bookbinding

This book is for
Chip, Jeanne, Debbie,
and Grandma Webster
who made it all
possible.

CONTENTS

"PAIGE'S PLACE"
16x20 Oil on Canvas

This is one of my first indoor paintings and a favorite. While visiting at Paige Gillie's uniquely renovated old home, a quick glance around told me there were many picture possibilities, and a number of paintings later materialized. The single window provided my light source which, on the two mornings it took to complete this painting, was cool and pearly, giving the room a quiet dignity.

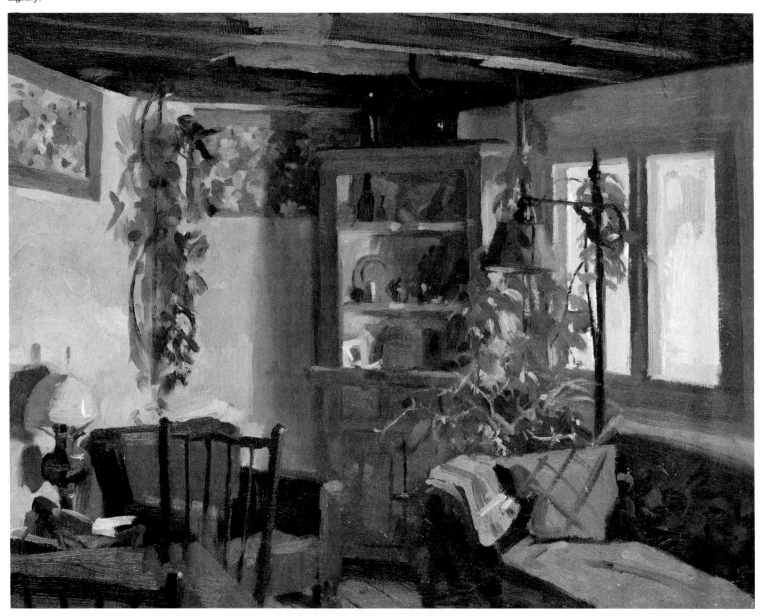

INTRODUCTION

For years I've been intrigued with the endless material, paraphernalia and worldy trappings with which we surround ourselves. Daily we encounter this wonderful, personal stuff but seldom do we sense or recognize the remarkable picture opportunity it presents. Around us is a familiar yet undiscovered world full of potential pictures. The possibilities are almost everywhere. Walking up a stairway and seeing an open door, beyond a room with sunlight catching the corner of a chair, a person relaxing on a sofa with a small lamp intimately illuminating the scene, a mirror reflecting something familiar in an unexpectedly new way. Looking through some plants to the corner of a room where a child is playing. These are some of the scenes that have provided me with material for numerous drawings and paintings.

Painting indoor scenes also solves a number of problems encountered when working outdoors. How much easier painting is without a dependence on weather conditions, transportation to and from locations and a constantly moving light source. You can paint at your leisure without bothersome onlookers. You're painting things you know intimately and this will give your work added interest and feeling.

Artists such as Van Eyck, Vermeer and Rembrandt painted indoor scenes. Though the Impressionists are known chiefly for their outdoor paintings, they also painted colorful indoor pictures. Some of Vincent Van Gogh's most personal statements are scenes of his room and its belongings. Edward Hopper painted pictures indoors, and more recently, Andrew and Jamie Wyeth have carried on this tradition with watercolors and temperas of their interior world. Our society seems to demand more and more of our time while giving us less opportunity to express ourselves. Do-it-yourself projects are popular. All too frequently though, the manufacturers take most of the challenge and fun out of the project and you end up at the mercy of predictable instructions, assembling pre-numbered parts. Where is the challenge? Where is the fun and satisfaction? Where is that " I may not be able to pull it off, but if I do, it'll really be fun so I think I'll try" attitude that more independent activities like skiing, tennis and music present? Painting offers these challenges. Creating pictures can be as exciting as a mountain climb and when you paint a good one, just as exhilarating. Painting pictures makes you a fuller person. Whether your work verges on abstraction or is sharp focus realism, you're painting pictures that are you. Painting pictures indoors gives those unable to get outdoors an opportunity to work from the real thing. As you read this, open your eyes, there's a world of pictures around you. It is my hope this book will help you to see those pictures and turn them into fine paintings.

Charles Sovek
Westport, Connecticut 1979

CHAPTER 1
Materials and Set-up

Contrary to what the ads for the art suppliers imply, you don't need a suitcase full of materials to create worthwhile pictures. In some cases very few materials will suffice. I recall watching my friend, Roger Vernam, in a sketch class one evening drawing on cheap newsprint with a piece of charcoal about the size of a nut. The finished drawing had the quality of an Old Master. Total cost of materials couldn't have come to more than about 7 cents!

Lautrec worked on cardboard and John Constable would occasionally paint on paper. A well-known illustrator, Austin Briggs, in his earlier days, worked on old window shades. What you work with is incidental. The important thing is to find out what materials are right for you.

One way of starting is to take inventory of your existing supplies and build on those. I must confess to being an addict to art materials buying all the "revolutionary new" products, using them a couple of times, then putting them away to gather dust while I go back to my old reliables.

Over the years, I've become more and more convinced an artist can make many of his own supplies, perhaps not paint or brushes, but many of those expensive extras like: mahl sticks, brush washers and containers that keep your pigments wet. If you're handy you can save a considerable amount by making your own equipment. I believe it was Somerset Maugham who said he envied artists and thieves as being in the only noble occupations where one could make his own tools!

Let's break the materials down into two categories: what you work on—easels, sketchboxes—and what you work with—paints, brushes and palettes.

There are many easels on the market today and common sense can dictate your needs. Art supply stores have catalogues with many kinds of easels to choose from. My

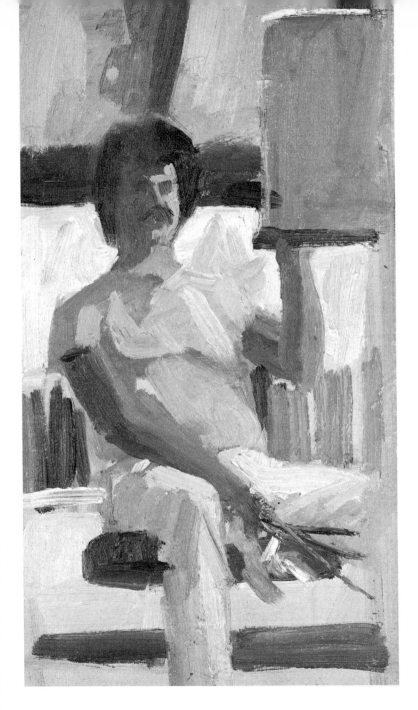

This little painting originally was about two inches larger all around. I cropped it to give the composition a more intimate quality. The various gestures artists assume while painting has always intrigued me. One day I happened to see myself in a mirror while working and I couldn't resist turning my slouchy pose into a painting.

preference for indoor painting is the popular French Easel. Though made for the outdoor painter, I find its portability and easy adjustment to either standing or sitting positions ideal for indoor work. Another and more simple set-up is the painter's sketchbox opened and set on a chair with the lid of the box acting as an easel. When you sit in a chair facing the paint box—everything is accessible and you're ready to paint.

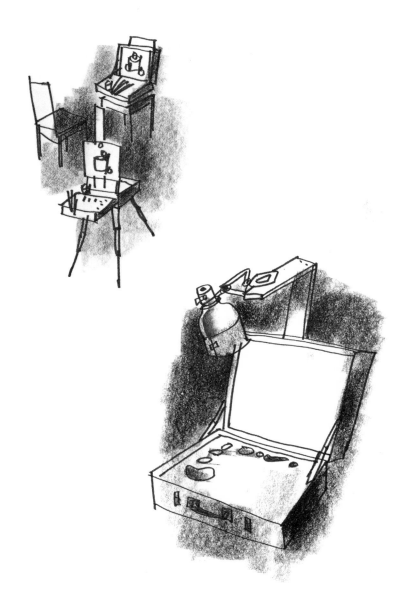

The next requirement is to have the same light hitting our canvas that lights the scene we want to paint. Why? A simple solution would be turn on another light or two to illuminate everything, but it's not so easy. The overall lighting is changed and the scene that originally intrigued you may not look the same! What was intimate and charming before now takes on the lighting conditions reminiscent of your local discount store. This problem, however, can be easily solved with a light and reflector built into your paint box. These are inexpensive items available at many hardware stores. Add to this one warm or one cool 50 watt bulb and a strip of paper to form a shade on the light reflector. Two pieces of thin wood and a bracket to hold it together will put you in business.

A word about warm and cool light bulbs. Most lamps in homes use warm light bulbs whereas daylight coming through your window –overcast or sunlight– tends to be cool, and in order to get accurate color, you should have the same light on your canvas as is shining on the scene you're painting.

The chart on the following pages lists six popular artist's mediums, what is good and bad about each, and what you need to get started. As you use any of these mediums and become more familiar with them, you may want to substitute or add items. In time you may want to combine mediums for different effects—be my guest.

Ralph Mayer's *Materials and Methods* is a good reference book and will give you any additional information you might need. I recommend it.

MEDIUM	IDEAL KIT

Watercolor

Small box to hold equipment. Fishing tackle box works well.
Large flat 2″ sable.
Round #7 sable.
Round #3 sable.
Rigger #2.
Flat #5 sable.
Bristle Brush for scrubbing.
Large paper clips for attaching paper to board.
Palette (butcher trays make the best; avoid the ones with all the little compartments—no big areas for mixing. The John Pike Palette is ideal).
#2 office pencil
Paper towels (some watercolorists use facial tissue).
Sponge.

Paints:

Burnt umber	Burnt sienna
Alizarin crimson	Hookers green
Cadmium red light	Thalo green
Cadmium orange	Thalo blue
Cadmium yellow pale	Cerulean blue
Cadmium yellow medium	Ultramarine blue
Yellow ochre	Ivory black

Pen & Ink

Small box for holding equipment.
At least 3 pen holders.
A variety of points for various effects.
A good #4 round sable brush.
A worn round sable for dry brush techniques.
Small tube of waterbase white paint for corrections.
Razor blade for scratching out whites.
#2 office pencil for preliminary drawing.
2 erasers: Kneaded eraser for erasing pencil lines.
Typing eraser for removing pen lines and ink smudges.

Pencil

Small box for holding equipment.
Paper clipped to drawing board.
Sketch book.
At least 4 pencils: 4B-very soft
2B-soft
HB-medium
2H-hard
Stick of Conte crayon (soft).
Couple of sticks of charcoal (hard and soft).
Charcoal pencil (medium).
Grease pencil.
Erasers: Kneaded eraser
Pink pearl
Erasing shield for corrections.
Razor blade for scratching out whites.

MEDIUM	IDEAL KIT

Oil

Paintbox 16 x 20 inches.
5 Flat Bristle Brushes (#2, 4, 6, 8, 10) for general painting.
1 small medium priced #2 pointed sable for details.
1¾″ flat sable for occasional blending of tones.
Palette knife—Painting knife.
2 palette cups—1 for turpentine.
1 for painting medium (½ linseed oil, ½ gum turpentine)
Brush washer.
Roll of paper towels.
Palette (tear-off sheets or frosted plexiglass cut to fit sketchbox).
Razor blade in holder to scrape excess paint from palette.

Paints:

Titanium white	Burnt sienna
Burnt umber	Permanent green light
Alizarin crimson	Thalo green
Cadmium red light	Cerulean blue
Cadmium orange	Thalo blue
Cadmium yellow pale	Ultramarine blue
Cadmium yellow medium	Ivory black
Yellow ochre	

Acrylic

Paintbox (same as oils).
1 #6 medium priced round sable for thin washes.
1 #8 medium priced square sable for thin washes.
1 #2 medium priced round sable for details.
3 nylon square brushes #4, 6, 8 for thick opaque painting.
Palette cup for acrylic medium (either matte or gloss).
Container for water.
Paper towels.
Tear-off paper palette or frosted plexiglass (wooden palettes don't work well).

Paints:

Titanium white	Burnt sienna
Burnt umber	Permanent green light
Naptha crimson	Thalo green
Cadmium red light	Thalo blue
Cadmium orange	Cerulean blue
Cadmium yellow pale	Ultramarine blue
Cadmium yellow medium	Ivory black
Yellow oxide	

Pastel

Boxed pastel set.
Drawing board with at least 6 sheets of paper to form soft backing to work on.
Rags or paper towels to keep hands clean.
Fixative spray.

MEDIUM	ADVANTAGES	DISADVANTAGES
Oils	It's easy to work wet and manipulate the paint. Doesn't dry to a different value.	Sticky, messy. Drying time is slow unless drier is used. Colors aren't as brilliant as acrylic or watercolor.
Acrylics	Easy to combine thick and thin paint back and forth. Dries rapidly. Permits easy glazing.	Colors dry darker. Loss of brilliance until varnished. Once dry can't be changed. Difficult to manipulate subtle modeling of flesh. Hard on brushes
Watercolor	Spontaneous. Very portable. Ideal for indoor painting.	A one shot deal. Can't be overworked. Can have a thin surface look.
Pastel	Very portable. Easy clean-up. No brushes. Easy to manipulate and change. Can work loose or tight and precise.	Can easily be overworked. Extremely fragile surface that needs to be covered immediately or it will smudge. Fixative tends to darken colors.
Pen & Ink	Good sketch medium. Rich range of values with bold line or very fine line.	Requires time to get good quality; unlike pencil where you can work very quickly.
Pencil	Good for either tonal or line work or a combination of the two.	You have to "push it" unlike pen and ink where the line literally flows from the end of the pen. Some people like this "push"—some not. Try both and use the one that feels right.

MEDIUM	BEST SURFACES TO WORK ON
Oil	Stretched canvas. Canvas board. Masonite with a couple of coats of acrylic gesso. Upsom board with a couple of coats of acrylic gesso.
Acrylic	Canvas (acrylic primed). Masonite (acrylic primed). Upsom board (acrylic primed). Illustration board. Watercolor paper—High rag content best. With acrylics you can paint on virtually any surface including glass.
Watercolor	Watercolor paper (100% rag content best). Watercolor block (100% rag content best). Illustration board. Bristol board or paper.
Pastel	Pastel paper. Illustration board. Brown wrapping paper. Usually a toned paper works best.
Pen & Ink	Bond paper. Bristol board. Illustration board.
Pencil	Bond paper. Newsprint. Layout paper. Illustration board. Vellum. Sketch book paper is ideal.

CLEAN BRUSHES WHILE WORKING

Keeping colors fresh and clean in oils is always a problem. I find that by using two separate brush washers, wipers and medium cups, one for light colors, the other for darks, I can keep the colors and values clean. A good color mixture can be destroyed by accidentally getting some dark into your light or vice versa. I also use different brushes for lights and darks.

STORING BRUSHES

I have two large, flat baking pans in my studio which save me hours of work. One contains paint thinner for my wet oil brushes, the other holds water for my wet acrylic brushes. I cut two pieces of stiff wire screening (hardware cloth) to fit the pans. The screen is moulded to form a slope to one end. The brushes are placed on the sloping screen so the business end is submersed and the handles are clear of the liquid. The brushes stay soft indefinitely. Before putting the brushes on the screen I make sure they are reasonably clean by first swishing them out well in the appropriate cleaner. If you store the brushes for any length of time (a week or more), be sure to check the water or thinner level as evaporation will occur.

14

WATER CONTAINERS

An army canteen and cup is a good solution. Or an old detergent bottle can be used to carry the water. Another slightly larger bottle with the neck cut off works well as a cup. The smaller bottle can be nestled onto the bottom of the larger one for transporting.

INK HOLDER

A piece of cardboard with a hole cut into it to fit around the neck of your ink bottle then taped to your sketchbox will help prevent spills.

MAHL STICKS

Some painters like to work with a mahl stick. You can buy one. The most practical is the kind that breaks down into three pieces so that it can be stored in your paint box. Or, you can easily make one. An ordinary curtain rod will work. The curved neck makes a good rest on the edge of the canvas. An 18″ wooden ruler or yardstick can work well also. I don't use a mahl stick often, however there are painters who use one all the time. Try one, you might like it.

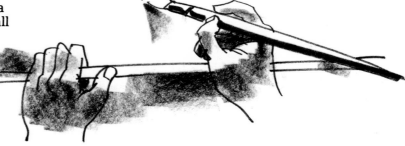

VIEWERS

Looking through an empty 35mm slide holder helps to visualize possible pictures. Move it back and forth in front of your eye until you capture an interesting composition.

A more elaborate version can be constructed by mounting a piece of clear acetate on a mat (any size you find convenient) and draw thin grid lines on the acetate as shown in the sketch. If you wish you can then draw another grid, in proportion to your viewer grid, directly on your drawing or painting surface. In this way you can easily transfer what you see through the viewer to your paper and hold it all in reasonably accurate proportion. You can think of these aids as training wheels on a bicycle. With enough training you'll no longer need them.

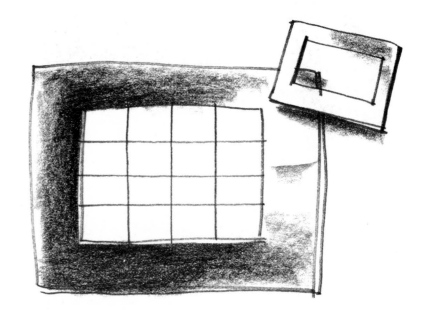

PALETTE AND PAINTING KNIVES

There are two basic types of knives. Painting knives are quite flexible and come in an almost endless variety of sizes and shapes. Palette knives are stiffer steel and look something like common butter knives. When working in oils, I use the palette knife to scrape out mistakes and scratch in new drawings over wet paint. I find the painting knife useful for scraping off excess paint from my palette as well as putting paint on my picture.

Working in acrylics, you can use either knife to apply paint. Because it dries quickly, however, it is difficult to scrape out.

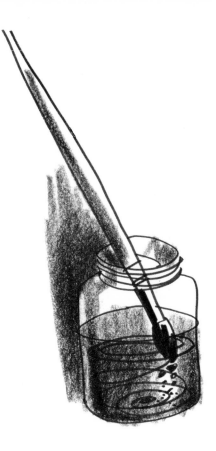

BRUSH WASHERS

Excess paint can be removed from your brushes by using a brush washer. You can buy one or you can make one easily. An old peanut butter jar with a coat hanger bent in a spiral to fit at the bottom is all that's needed. When you swish your brush in it, the old paint floats to the bottom and you don't stir it up every time you clean your brush. Fill with odorless paint thinner when working in oils and water when using acrylics.

TURPENTINE AND ODORLESS PAINT THINNER

I use both of these products. Gum turpentine thins the paint nicely and dries quickly. The paint thinner is best used for cleaning brushes. Some artists use paint thinner for everything. If you happen to be allergic to turpentine, thinner is an answer. Other painters prefer turpentine for both medium and brush washer. Personally I don't like the gummy residue that turpentine leaves on the lip of the washing jar making it hard to put the top on. Again, I suggest you try both and use the combination that works best for you.

WRAPPING BRUSHES

When working away from your studio, a good way to keep your brushes wet is to wrap them up. With oil brushes, dip them in paint thinner and without drying, wrap them in tin foil. Fold the foil carefully to seal the brushes in. This will keep them in good shape for about a day.

Treat your acrylic brushes the same way except dip these into water and wrap them tightly in foil. Be sure to promptly wash them out when you get home. In case the acrylic brushes get hard, alcohol can be used to get the dried paint out. It usually works.

SAVING PAINT

Oil paint is the easiest to save. A pan filled with about 2″ of water and a piece of glass is all you need. Put the leftover paint on the glass, lower it into the water and your oils will stay fresh and wet for days, even weeks. Don't be hesitant about submersing the paint into the water—oil and water don't mix.

Saving acrylics is a bit more complex. An air tight container with a wet sponge will keep them for a couple days. Put them on a piece of glass before enclosing them in the container. Some artists squeeze the acrylics on wet paper towels instead of using a sponge. Others use a water sprayer and give the paints an occasional misting of water.

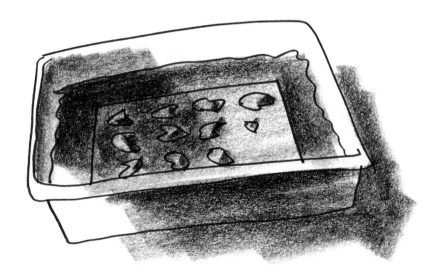

Watercolor offers no problem. Leave excess color on the palette and by re-wetting, they become moist again. The paint tends to be less juicy this way. I usually squeeze a fresh gob of wet paint on top of the old dry one just before I start painting.

A good tip for storing unopened paint tubes is to keep them in the refrigerator. The moisture will keep them fresh.

BRUSH DAUBER

An old tuna fish can makes a fine container to wipe off brushes. The can is shallow enough to put in your paint box and still close the lid. Stuffed with paper towels or a rag, the tuna can makes an excellent dauber to absorb most of the wet paint and turpentine after it has been swished in your brush washer.

FILLING PEN POINT

If your pen point becomes clogged the line won't flow. Sometimes this is caused by dry ink or residue clogging the breathing hole. To insure a good clean flowing line, fill a small glass (a whiskey shot glass is ideal) with only enough ink to fill the pen point just short of its breathing hole. You can now dip into this easily without worrying about over-filling.

RAZOR BLADE IN HOLDER

Nothing is better for cleaning your glass or plexiglass palette than a single-edged razor blade in a holder. When you're not using it, put it in a small jar filled with enough paint thinner to cover the blade. This keeps the razor free of dried paint so the blade can scrape easily and without resistance.

WIRE PASTEL BOX

Some artists who work in pastel like to use a box with a wire mesh shelf which is slightly raised off the bottom. This lets all the crumbly small particles of excess pastel fall through the screen, preventing them from getting mixed in with the full pieces and contaminating their color.

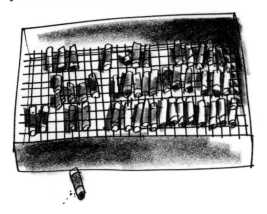

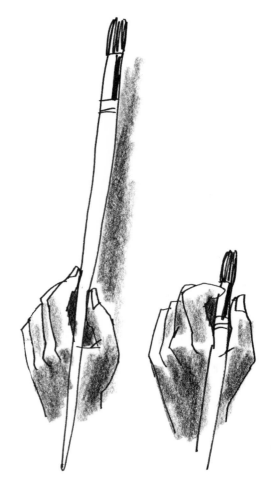

HOLDING THE BRUSH

There are two basic ways I hold a brush. Most of the time it's with my arm extended and my hand holding the end of the handle. This permits a good overall look at what I'm painting while I'm painting. I usually stand when working, and holding the brush at the end forces me to think big, avoiding a finicky "noodled" approach which ruins many paintings.

When I'm ready for details, I hold the brush close to the ferrule with the end of my little finger carefully resting on the painting.

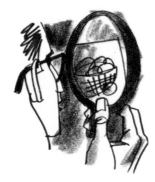

MIRROR

A mirror is useful for occasionally looking at your pictures in reverse. We sometimes become blind to our pictures after working on them for long periods of time. A look in the mirror at the reverse image will quickly show up mistakes.

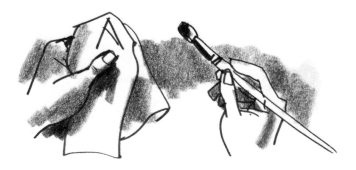

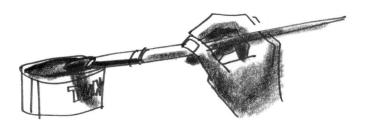

3 Daub brush on paper towels stuffed into a can.

CLEANING BRUSHES

1 After you've made a stroke in oil or impasto acrylic and want to clean your brush, hold the brush you're using in your painting hand and a couple of paper towels in the other.

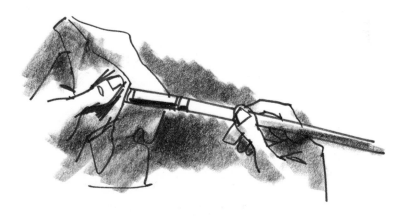

4 Wipe brush in paper towels held in hand to get out any final bits of unwanted color. Change paper towels in hand frequently as they become soggy after a dozen or so wipings.

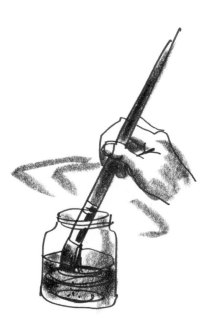

5 Now you're set to mix a clean color and be sure the old color in the brush has been wiped clean so it won't contaminate the new mixture.

2 Swish used brush in brush washer a couple of times.

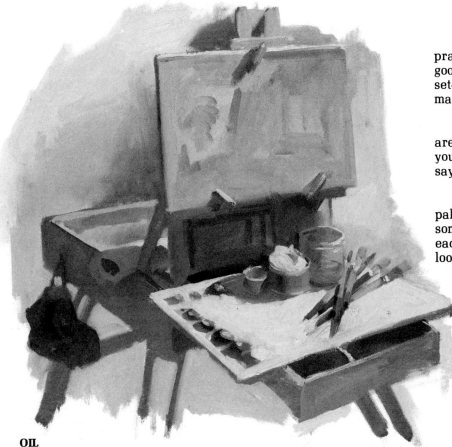

In much the same way a golfer, tennis player or musician practice strokes and scales, you, as a painter, should develop a good workmanlike approach to painting. Develop just the right set-up for your particular needs. No other artist may set up his materials as you do, but that's O.K. as long as it works.

You should strive to know your materials so well you aren't consciously aware of them. Only then can you devote your energies to the scene in front of you and what you have to say about it.

I've seen photographs of Monet's, Cezanne's and Pissarro's palettes. They look like much played instruments—used and in some cases, paint encrusted. Still evident, though, is an order each of these painters had in his own way. You only have to look at their paintings to see this and order shine through.

OIL

Most of my oil painting is done on a French easel. An old army canteen cover holds the jar filled with paint thinner for washing brushes. The palette is white plexiglass cut to fit inside the sketchbox. Paint lined up around the edges gives me a mixing area in the center of the palette which I can scrape clean when it gets filled with paint.

WATERCOLOR

My watercolor set-up is the simplest of all. And, except for the water, the most portable. A gallon detergent bottle with the bottom half of a slightly larger one to nestle into the first, provides plenty of water and something to hold it. The palette is the John Pike model. Paper towels and a brush dauber complete the set-up.

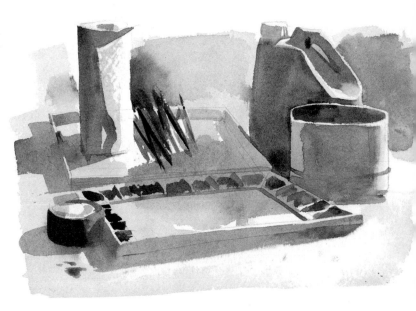

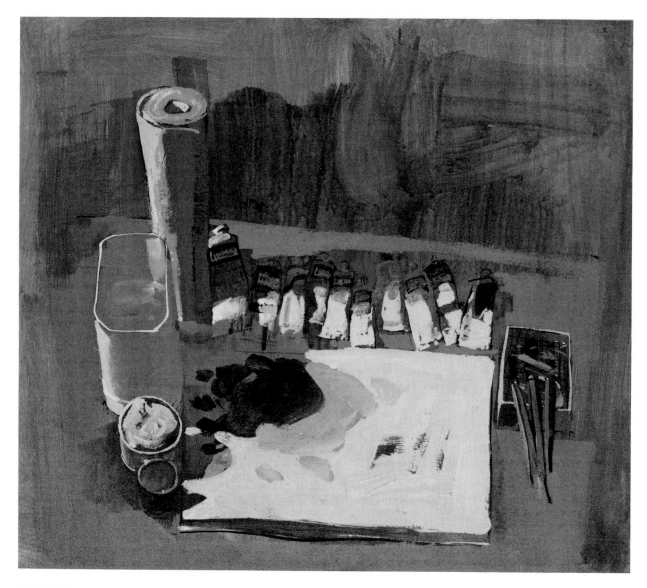

ACRYLICS

This is the way my acrylic set-up usually looks. The palette is the paper tear-off kind. The container holding brushes is full of water so the paint won't dry in my brushes. The small medium cup holds acrylic for thinning paint. As in all my other "wet medium" set-ups, paper towels are a must.

CHAPTER 2
Drawing

What does it mean to draw? I've asked this question to my students, fellow artists and friends, and have looked up definitions by famous painters and artists. Here are a few notable quotes:

"A drawing is an idea with a line around it."
Elliot O'Hara

"Drawing is not following a line on the model, it is drawing your sense of the thing."
Robert Henri

"The essence of good draughtsmanship seems to be to make oneself understood."
Robert Fawcett

"Drawing is making things look real on paper."
Jeann Sovek, age 8

"A drawing should not mean, but be."
Archibald MacLeish

How interesting and varied these answers are. Your definition,too,should be unique to your particular interests, backgrounds and needs.

I first discovered drawing as a child, watching my father who was a carpenter. To him, drawing was precise and accurate, a way to help him build things correctly. Straight lines crisply overlapped each other and the tool used was usually a short, stubby pencil. To me as a child, this was drawing. It wasn't until I was in art school that this limited idea of drawing gave way to a broader definition and I acquired many new ways of seeing and expressing myself. My new concepts mixed with the old and my particular way of drawing began taking shape.

Unfortunately, many people associate drawing with precision and rigidity. How many times have you heard the expression "I can't draw a straight line without a ruler."? Well, who can? Even if you could, does that mean you can draw? Obviously not.

Watch a child draw. He's completely absorbed in what he's doing. The effort in recreating the object on paper is total. All

the senses are used. The sound effects made are very real as his airplane soars across the paper. To some it's silly meaningless scribbles. To the child it's his total knowledge of the subject seen through his senses. I've given my children many different things to draw with, encouraged their originality and occasionally was envious of their results. "Look pa, no ruler."

I'm not saying throw away discipline, craftsmanship and rulers. I am saying to learn to use workmanlike procedures as tools to help explore all those wonderful scenes and objects that surround us every day.

Sometimes training can hinder your personal approach to drawing, especially if you're taught a manner that may be right for the teacher but not be right for the student. You draw best when you draw naturally and the way you enjoy it. Start by choosing a tool that you want to use. Next, ask yourself why you're drawing. It could be to simply put on paper an interesting scene you see in front of you and the drawing itself will be a finished statement. Or you might be drawing for information which will be combined later with other drawings or used as the basis for a painting. Such drawings are usually loaded with notations of color, values, textures—written as well as drawn. Then there are sketches done to explore a subject. The same scene is drawn from different positions, searching for a point of view that looks best. This is drawing to clarify what you see. The real test of a good drawing, however, is not only how much you *saw*, but how you *felt* about what you saw. When you can communicate your feelings into a drawing, your talking about art. Oddly enough, this route takes us back to the child again.

I advise my students to jump right into a drawing. It's soon discovered what comes naturally and what's difficult. People approach drawing in two basic ways. Line drawing—everything is shown with a line around it; and tonal drawing—representing what's seen in shapes of light and dark tones. There are, of course, many combinations of the two. Both types of drawing are built on good proportion—the subject of this chapter. Shapes and values will be covered later.

SARDINE CANS

On the following pages are five people drawing the same object. Which one do you like the best? How would you interpret a sardine can? When I gave my artist friends one of these interestingly shaped objects, I told them to draw it in a way that communicated best their particular view of the can. Seeing all these drawings together, I can easily tell what artists did which drawing. Each caught the essence of the object but in his own way.

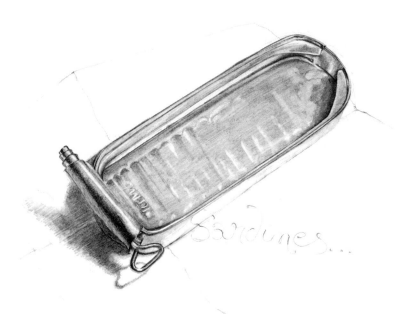

DEBORAH DUTKO-SOVEK

26

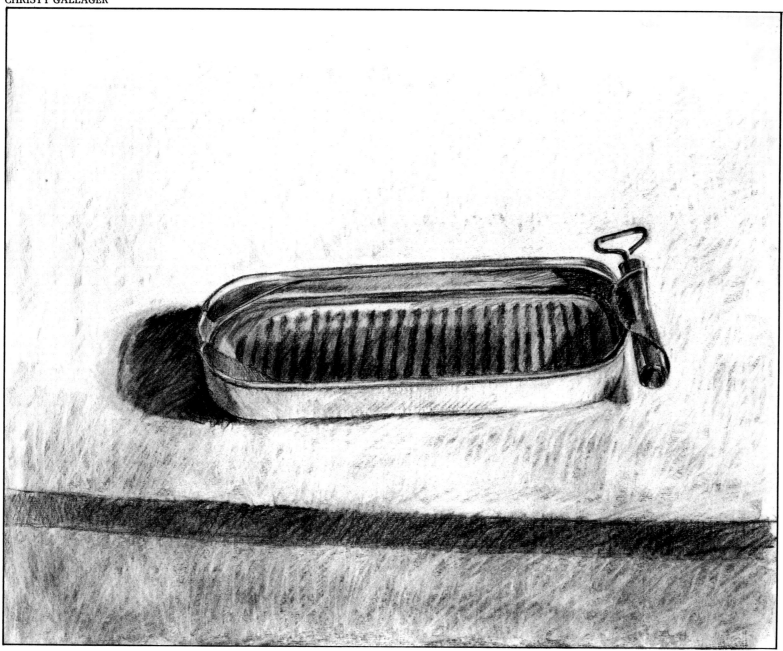

BERT DODSON

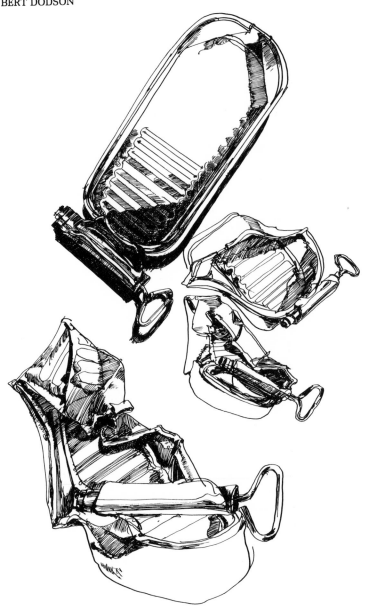

HOWARD MUNCE

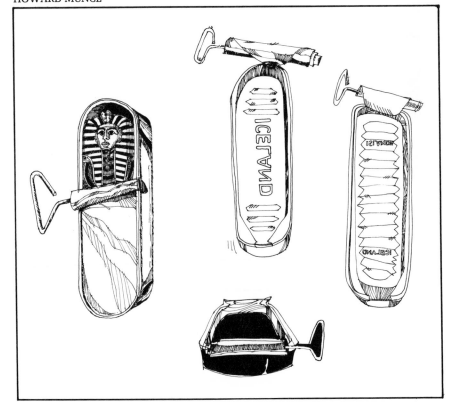

28

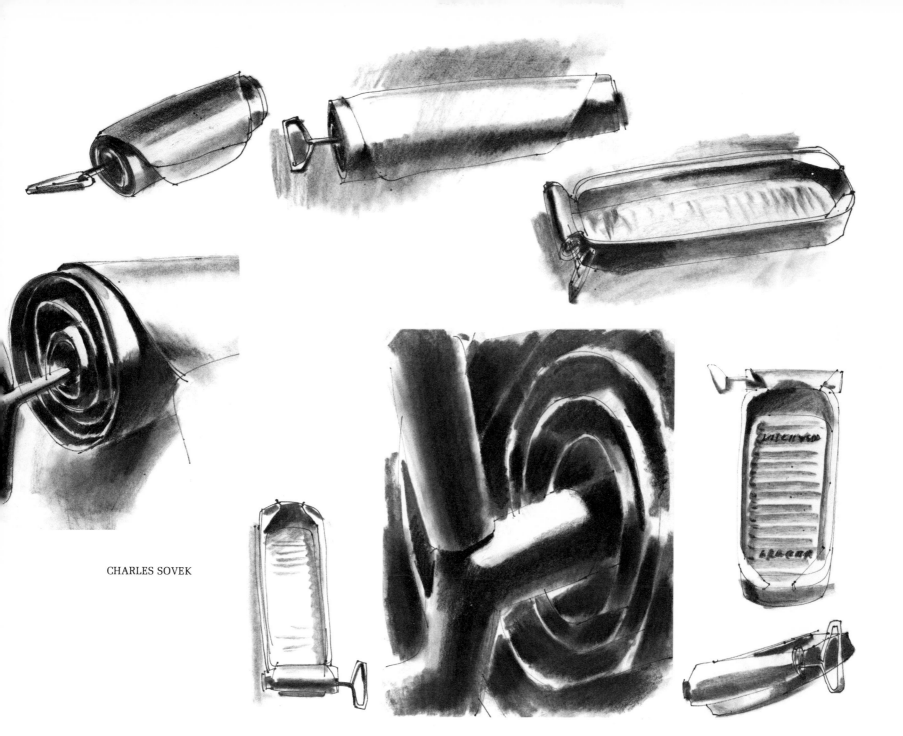

CHARLES SOVEK

Arrange a couple of objects on a table in front of you. A piece of fruit, a sugar bowl and a milk carton. Keep it simple. Hold up your pencil vertically aimed at the subject. What matches the upright position of your pencil? Perhaps the sides of the milk carton.

Draw a vertical line on your paper. This will represent one side of the milk carton. Make a mark where the top and bottom of the carton will be.

Holding your pencil up again, this time horizontally, see if it matches the bottom of the milk carton. If the carton's at an angle, it won't match. You will know, however, how much or little the line is angled. If the carton is at an angle, simply tilt your pencil until it's the same angle as the bottom of the carton. Hold your pencil at this angle to your paper and draw in the lines to complete the milk carton.

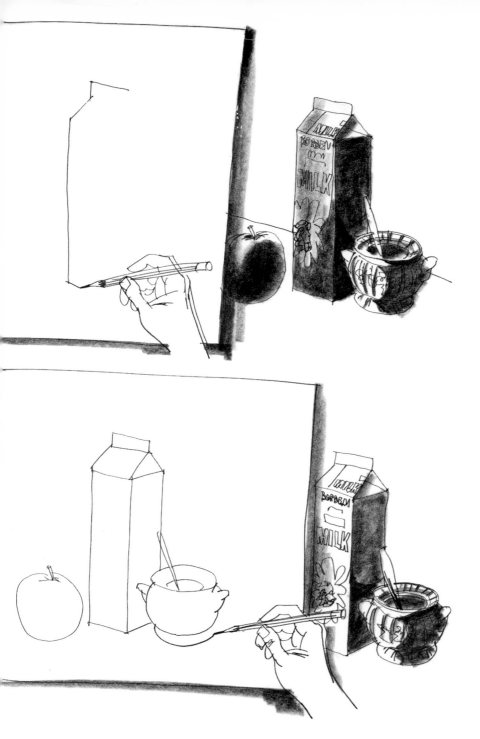

Again, holding your pencil in a horizontal position, where does the sugar bowl hit the carton? Perhaps half way or less. Make a mark on your drawing at the intersection. Sketch in the top of the sugar bowl—measure again to locate the bottom. Avoid small detail at this stage and go after the big forms. Keep holding up your pencil in horizontal, vertical and angled positions while transferring the information to your drawing.

Once the large forms are indicated, start working on the smaller ones. With some practice you'll find you have to hold your pencil up less and less to check your accuracy. Like the viewfinder mentioned in the last chapter, these methods are temporary aids. After drawing a couple of simple still life set-ups you'll want to try a corner of a room—a table, chair and part of a wall.

HEIGHT

WIDTH DEPTH

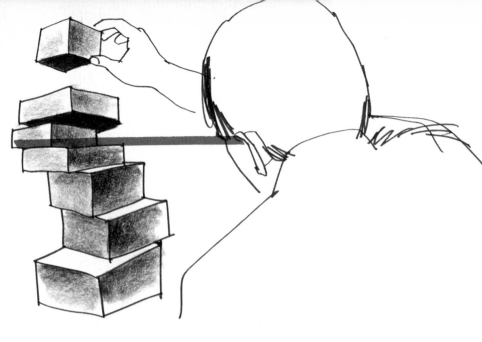

Perspective scares many people. Thoughts of T-squares, large drafting tables, razor sharp lines accurately placed—railroad tracks and telephone poles leading to infinity give them the shudders. This needn't be the case. Perspective is a tool like a pencil or a brush. Perspective really is making things look right. It's a way to make sure the vase on the table doesn't "look odd" or the table doesn't have legs of seemingly different lengths.

Perspective is showing how things look from where we are. As you look in front of you, certain things are lower than your eyes, some things even and others above you.

In the illustration the youngster's eyes are even with the blocks in the middle of the pile. Since the bottom blocks are lower he sees the tops of them and because the top block is higher than his eye, he sees the underside of it.

Another use of perspective is to give the illusion of depth in your pictures. In other words, to make things look three-dimensional having depth as well as height and width. To make your interiors look convincing, depth is just as important as height and width.

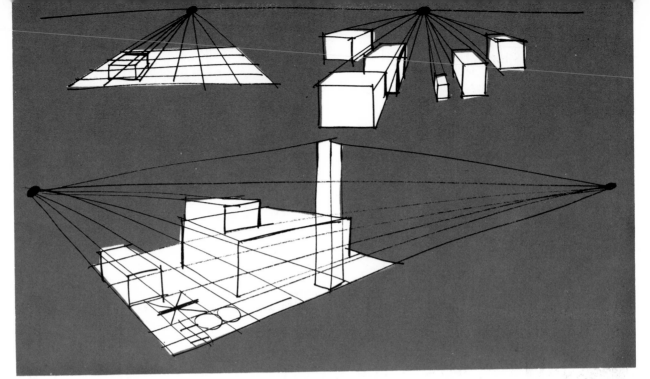

Two commonly used methods of achieving this three-dimensional quality are with the principles of one and two point perspective. Both methods are useful when drawing objects in a room. You can draw furniture and people to look believable and rest properly on the floor with a little knowledge of perspective. Of course, there is much more to perspective than these few pages show, and if you wish to delve more into the subject, you'll find many good books devoted to the subject.

Perspective can be a great help if used intelligently. There is a danger, however, in over-using it, giving your pictures a mechanical, impersonal quality. What you should strive for is your view of what you see, not an architectural rendering.

A good method to help you learn to make believable drawings is to draw freehand (no ruler) such simple objects as a match pad, bottle or toothbrush. Try to make these objects look convincing. If you have trouble, apply some of the perspective principles shown on the facing page.

Draw a room you live in. First sketch in the big shapes of the walls which are like the two corners of a big box. Then, as you did with the simple milk carton set-up, measure with your pencil and locate the large forms—a sofa, chair or coffee table. Don't be tempted to put in all those small details. Keep it simple and broad. Once you've established the big forms, step back and take a look. Does everything sit solidly on the floor? If not, it's easy to change and adjust things at this stage. When you have the large forms looking reasonably convincing, move on to the smaller objects. You'll be surprised to see how little detail you need to get the illusion of a finished looking room.

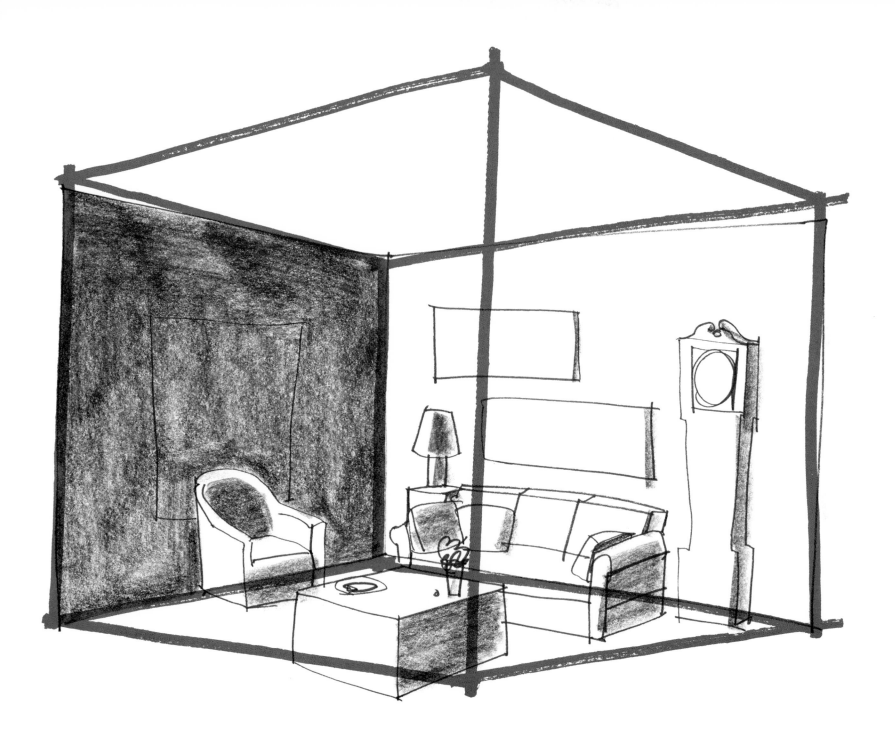

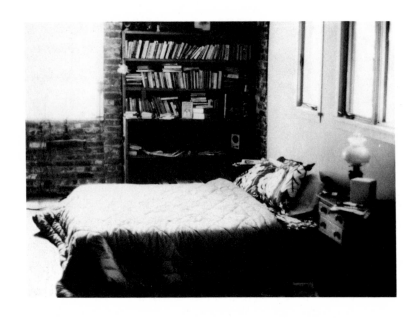

A medium sized sketch pad is excellent for doing these drawings. By limiting your time to not more than an hour on each one you'll force yourself to think simply. Later you'll be drawing small objects, furniture and the various details a furnished room contains, but first get used to drawing the whole room.

When you walk into someone's house for the first time, notice how no one detail stands out, rather the atmosphere of the whole room. Think about an interior you've been to recently. By first establishing the walls and the big box-like forms you then can draw detail without losing the feeling of the room's environment.

Once you gain some experience you'll want to try different kinds of drawing. You've discovered how important good proportion and correctness are—try now to combine this with gesture and the spirit of what you're drawing. A person slouched on a sofa, for example will usually look more natural if the gesture is slightly exaggerated. On the other hand the drawing of an old clock will require a more precise approach to capture its character.

Avoid drawing everything the same way. This has the double advantage of giving a particular quality to your drawing and it'll keep you out of a comfortable but sterile rut.

CHAPTER 3
Values and Pattern

These paintings are of subjects I had laying around my home and studio, ordinary things that might be around anyone's house. More important to me than the objects is the interesting value arrangements they make when light is shining on them. Notice how I've avoided most detail in favor of the large masses of tone, boldly placed. I feel the spirit of these forms has been caught. Values can be a great tool if you trust yourself to paint large masses, subordinating the details. If the values and shapes are right you'll be surprised how little else is necessary to convey the look of the objects.

The world of values is our next step into picture making. Equipped with a good sense of proportion and drawing we can now approach values with confidence.

In the previous chapter I said people saw things in basically two ways—linearly, which is a line drawn around things, or tonally, where values are used to define forms. We're now going to deal with values and the pattern you can create from the endless variations that exist in nearly everything we see.

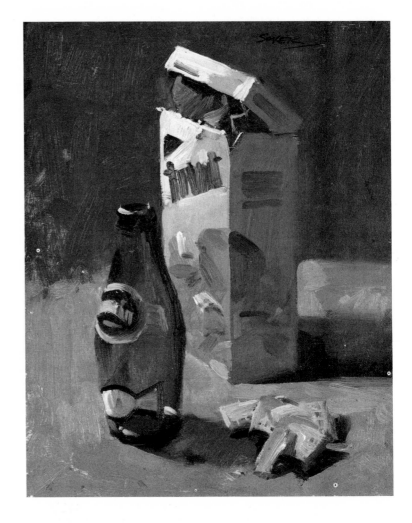

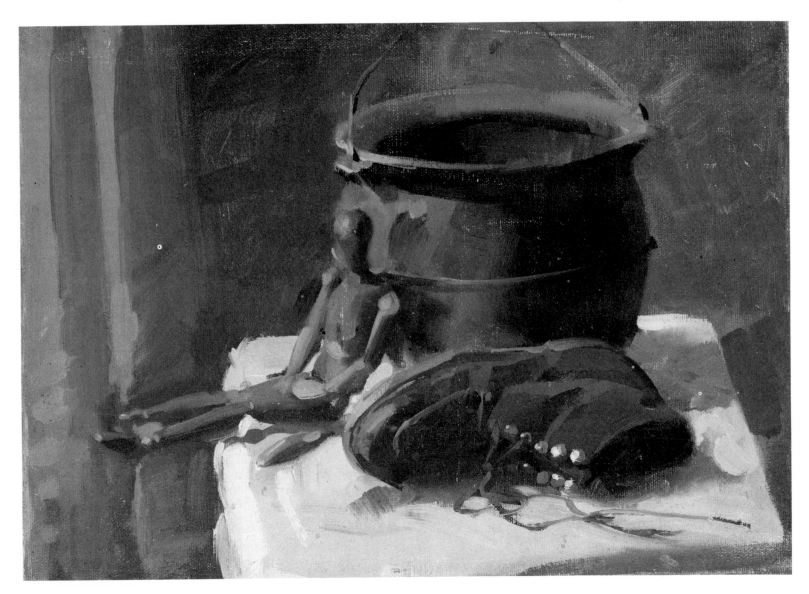

Value means the lightness or darkness of an object—or the various light and dark tones that appear to our eye when we look at something. Lay a white handkerchief on a dark bedspread—look at it—you see the handkerchief because it's lighter in value, then the darker spread. If you took a black and white photograph of the room you're in, the objects would be recognizable because of the values and the pattern they make when combined with each other. As artists, we want to show our own way of seeing these values and patterns. Go to a museum or look through reproductions of famous paintings and notice how each picture has a unique value arrangement and pattern. Making small copies can clarify even better the way values and pattern hold paintings together.

This practice need not stop as you grow as an artist. I recall being in Charles Reid's studio one afternoon. Lined up on a shelf were four or five empty oil paint boxes. Painted on the inside of each one of them was a copy of an Impressionist painting. Though the size was only three by four inches and the technique simply executed with bold brush-strokes, the little copies were alive and sparkling. The technique was simple, the values and pattern accurate.

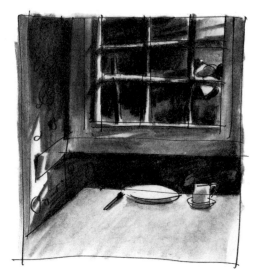

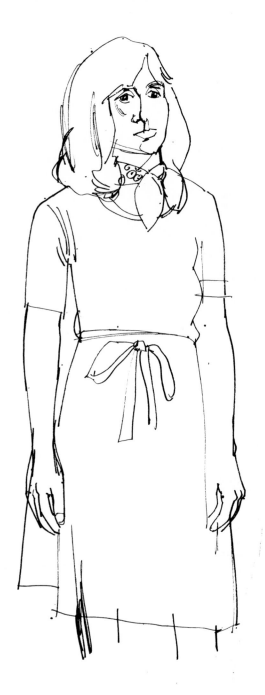

Let's face it, some people can see and identify values more readily than others. Doing a couple value studies will help you discover how you see values. Half the struggle is knowing how to approach values. Reproduced here is a value painting of my good friend Christy Gallager. Notice how her sweater looks white, hair and skirt dark, the flesh light and background dark. This all works because the values are correctly placed.

The two smaller sketches show how values are built on a line drawing:

1 A simple line drawing based on accurate proportion we get a likeness of Christy.

2 Observing what's light, medium and dark in value we show an even more believable likeness.

3 A light shining on Christy now shows which areas are light and dark *WITHIN THE AREAS OF FLAT PATTERN* shown in step two. Little else is needed to complete the portrait.

The key to controlling values successfully is simplification. We can't possibly show all the nuances of values we see in front of us. Try this exercise to show how few values we have at our disposal in any medium (pencil, paint, etc.) when compared to actual lights and shadows our eyes can identify.

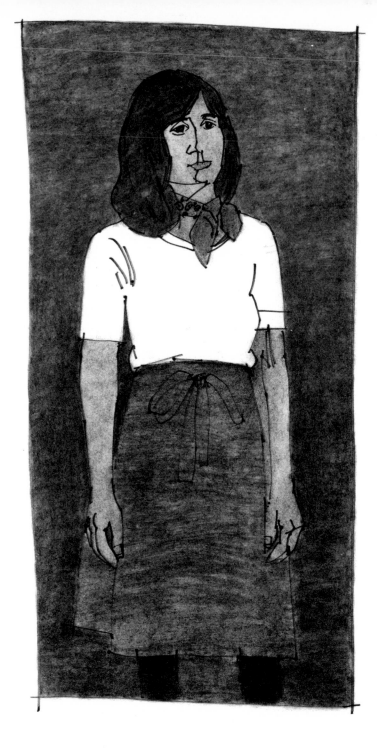

"CHRISTY"
Oil on Panel

Painting another artist is usually enjoyable, though once in a while embarrassing, especially if the picture isn't going well. This painting was done in one sitting of about two hours.

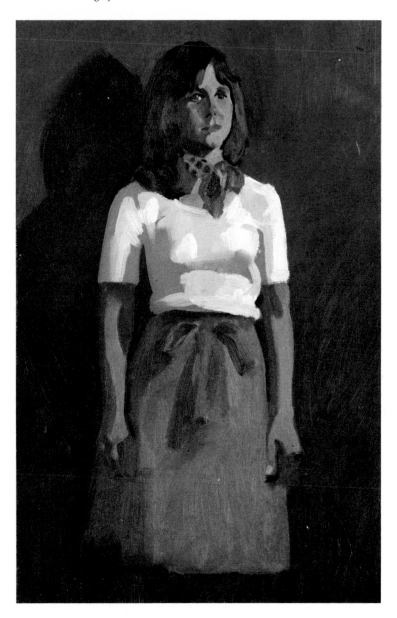

Take a piece of heavy white paper, an envelope is fine. With either black ink or a soft dark pencil, blacken a dark square in the middle. The paper will represent our lightest value—white. The dark square our darkest—black. Between the two is our whole range of values. It's impossible to go lighter or darker. Hold up the envelope to a bare light bulb. Notice how bright the light appears next to the white paper, making it look quite dark by comparison. Notice how close in value the dark square and white paper appear when viewed in this manner.

Squeeze out some black and white paint on your palette. Oils are best for this because they stay wet enabling us to pre-mix some values before we paint. However, any opaque medium will work.

Mix equal amounts of white and black. Using your palette knife, whip them together into a gray. Since some blacks are more powerful than others, you may have to add more white than black. We want a gray that looks halfway between white and black.

Take another gob of white and mix it with some of the middle gray, giving us a pile of light gray. Finally, make a pile of dark gray mixing equal parts of middle gray and black. Arrange these in five piles on the side of your palette (white, light gray, middle gray, dark gray and black). We now have the basis for interpreting what we see in front of us into a value painting.

There are value arrangements everywhere. Look around you, choose something that visually appeals to you and paint it. At this point some reckless abandon is important to help overcome timidity or fear of an empty canvas or board.

Working small, 8x10 or 9x12, first sketch in the proportions of your subject then fill in the shapes you see with the right value. At first use only the white, three grays and black without mixing other grays from them. Forcing yourself to simplify like this is the start of training your eye to see as a painter. As you gain awareness additional values can be mixed for more subtle tones.

Painters such as Fairfield Porter like to keep a simple value arrangement obvious in their work. Others, like Ken Davies, prefer to build up intricate detail. By simply turning one of Davies' paintings upside down, however, the pattern and value planning becomes evident.

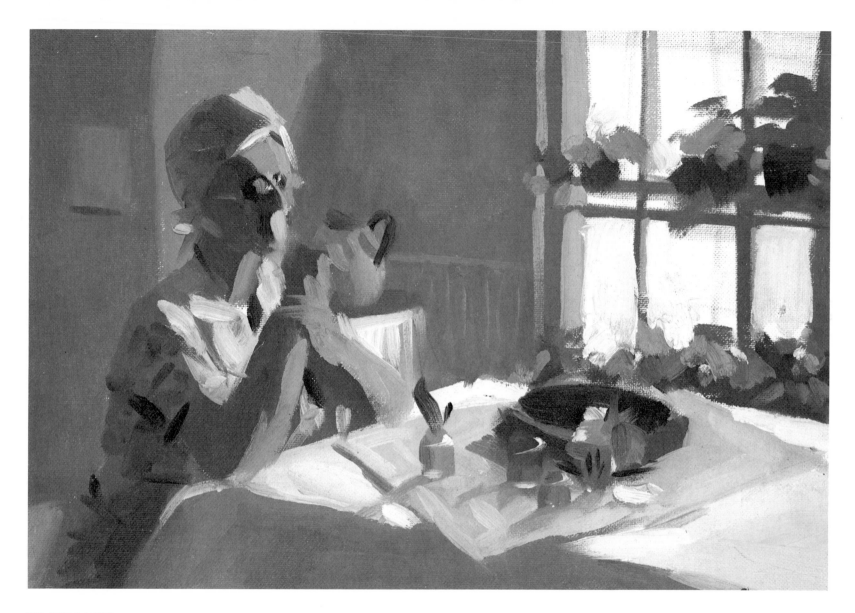

"PLANT LADY"
Oil on Canvas

I painted this picture in less than an hour. The values were boldly placed with a big brush. The lights and shadows were carefully considered and if you look closely at this painting, you'll see the light objects have lighter shadows than the dark objects. This is the key to getting the feeling of light in your pictures. Notice, also, the soft treatment of the edges.

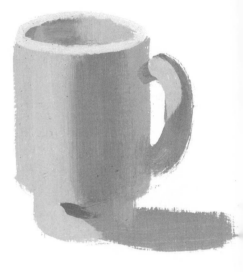

We'll deal more fully with light and shadow in the next chapter. It's important, however, to be aware of the light source that's illuminating the scene you intend to paint. Direct sunlight through a window or a spotlight will strongly break up an object into two distinct tones. These are called light and shadow. Other less direct sources like a small table lamp or light through a window on an overcast day will show less contrast. Finally, indirect fluorescent lighting will bathe the object with soft light showing only the slightest difference in light and shadow. See how many different kinds of lighting are in your environment. Interestingly, some objects which appear dull and uninspiring under one light source take on a whole new life when illuminated differently. Look at the paintings of the mugs and notice how each one takes on a different character with a change of lighting.

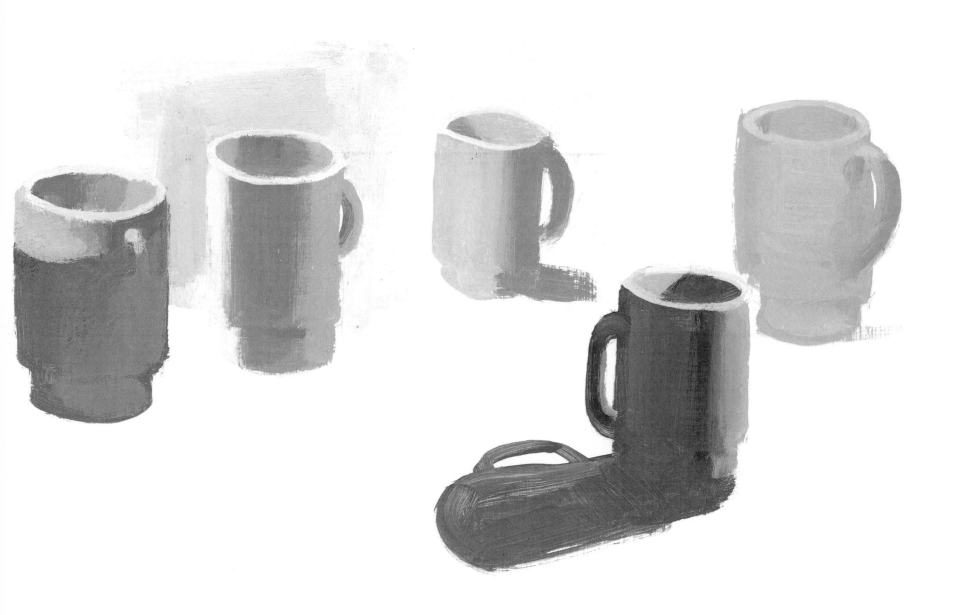

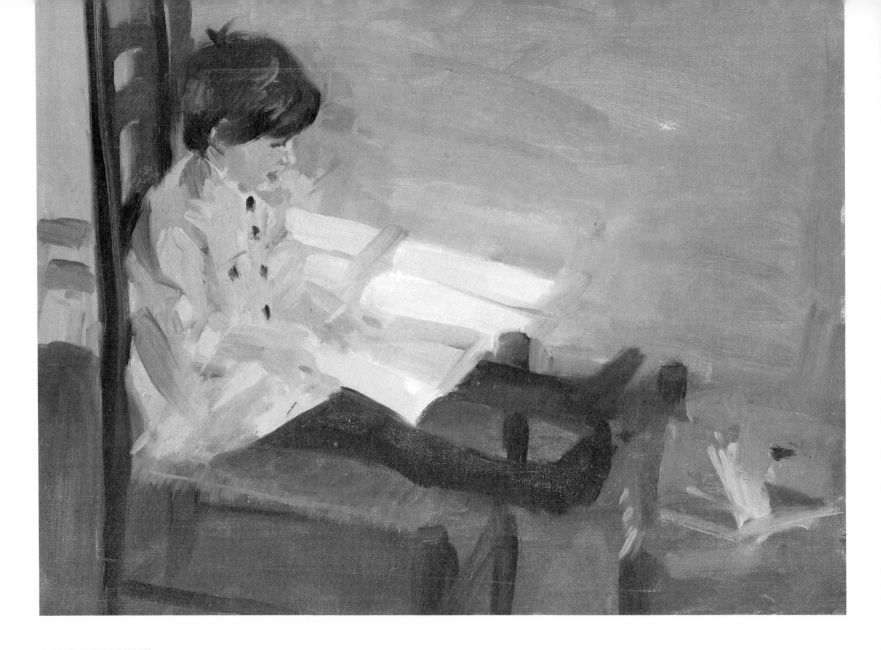

"JEANNE READING"

This is an example of sunlight shining in a room. When it's bright it makes a definite shape on whatever it's hitting. I saw my daughter sitting on a chair reading one day. She had just learned how and the story was totally engrossing to her. She was a good model for a while. The patch of sunlight in the room was painted lightest in value, almost white, and all the other values were lowered to make it look bright.

52

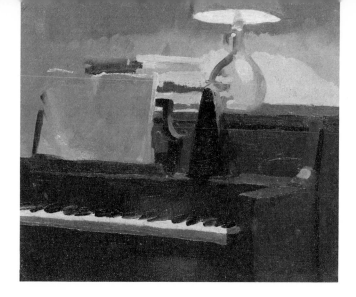

"STILL-LIFE WITH HAT AND FRUIT"
12x16 Oil on Canvas

The light shining on these objects was from a window on an overcast day. There are no hard cast shadows, only soft merging light, halflight and finally shadow. Many of the Old Masters favored this kind of light. While painting the apples, I was thinking of how many fine still-life paintings have been done over the centuries, most of them under this same kind of light.

"THE METRONOME"

Musical instruments are interesting objects to paint. A single lamp illuminating objects can create a pleasant mood. Many of the edges in the shadows merge and become hardly discernible. The area around the lamp is the brightest with values going progressively darker as they recede. I used a clip-on light attached to my easel when I painted this picture. More lights in the room would have ruined the mood.

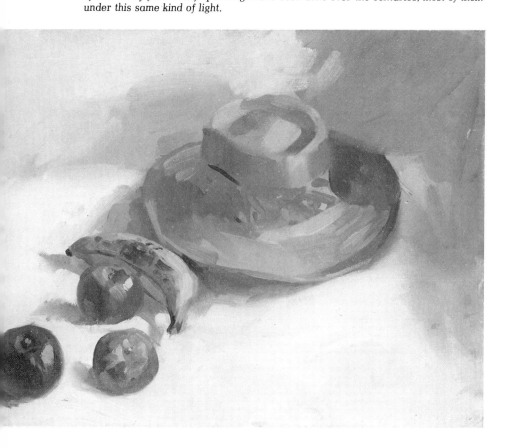

Up to now we've been simplifying our values. When confronted with a complex interior we now know how to show a room and all that's in it without getting too many busy, hodgepodge pieces.

By applying what we know about values and pattern, we're able to work simply while still suggesting the feeling and even some of the detail the room contains.

The painting I've chosen to show for this problem is the interior of my friend Mary Boulton's lovely New York apartment. Mary has collected many appealing objects of different sizes and shapes and arranged them tastefully. With my first view of her living room I saw it as a painting. However, it wasn't until I started making drawings of the setting that I discovered how difficult it was to show everything.

My picture became too busy. I was so eager to show the wealth of detail that I kept missing the look of the room itself. Detail can be a big temptation to overcome when painting a large, complicated room. Simplification was necessary or the painting would become a catalog of interesting pieces with little or no feeling for the room itself.

Because the room conveyed a great deal of Mary's warmth and friendliness, I used a soft, painterly treatment letting the edges of one object blend softly into the next. This not only helped me to subordinate details but gave the painting an atmospheric quality in harmony with the subject.

By squinting your eyes the value pattern is quite simple. Can you see how it is tied together with an overall middle gray value? Lights and darks are carefully placed to emphasize Mary sitting in her chair.

With each new interior comes problems unique to that picture. By approaching each painting as a particular problem, your chances of producing a good picture increase. Don't avoid a subject because it's too busy or the legs of the table look hard to draw or the subtle bluish color in the windows look impossible to match. By seeing each picture through, you'll grow more as an artist and be better equipped to face that next tough one that comes along.

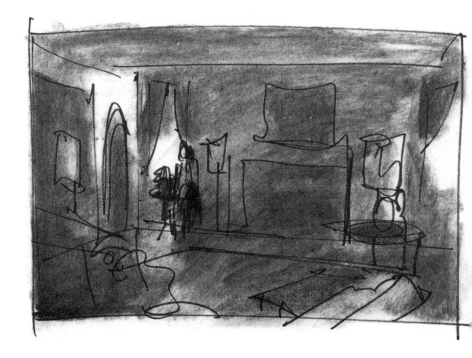

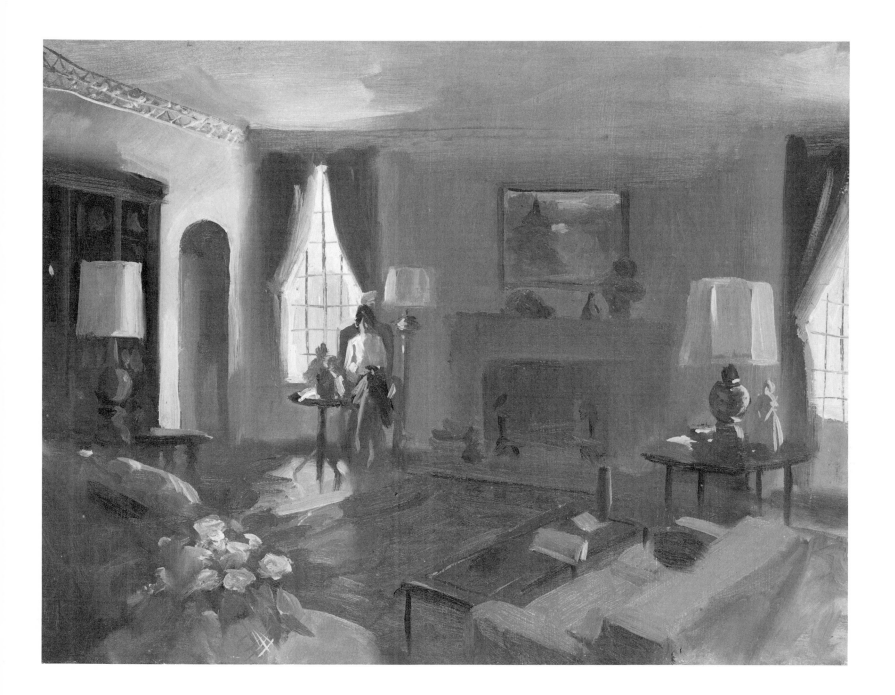

CHAPTER 4
Lights and Edges

The idea of painting light never occurred to me until an instructor in art school happened to say "Paint the light, and the rest of the picture will fall together." This was a real revelation to me. Up until then I tried to faithfully reproduce in values and color what was in front of me. Manet, when asked what was the most important thing in his picture, commented "the light!"

Discovering the kind of light that's shining on your subject can be an exciting pursuit. Look around and become aware of the kinds of light you see. At first the most obvious single light source, for example, a table lamp at night, will be difficult to paint. With experience, and concerned thinking about it, you'll begin seeing your environment in a new way. Light can be a fascinating study. Rooms, objects and even people can be instantly changed by the lighting under which they are seen. This is the stuff that makes painting exciting and a challenge.

Andrew Wyeth has based many of his paintings on observations of commonplace objects seen under interesting light. Apples lying in a field casting long spidery shadows, or a box of blueberries lit from the side with shadows from the box etching the forms of the berries, showing their irregularities. Light plays on things indoors with equal interest, so look more at the light and the mood it creates and less at the actual objects. I'll be surprised if you're not surprised by what you discover.

"CHIP"
Oil on Canvas

My son Chip was the model for this picture. He looks older, though he was only three when I painted it. The single light source from the table lamp gave me a chance to soften a lot of edges giving the painting a slightly out-of-focus, dreamy quality. This also enabled me to put the emphasis on Chip's head and shoulders. The playfulness of a child seems more easily captured when the technique is left loose and painterly.

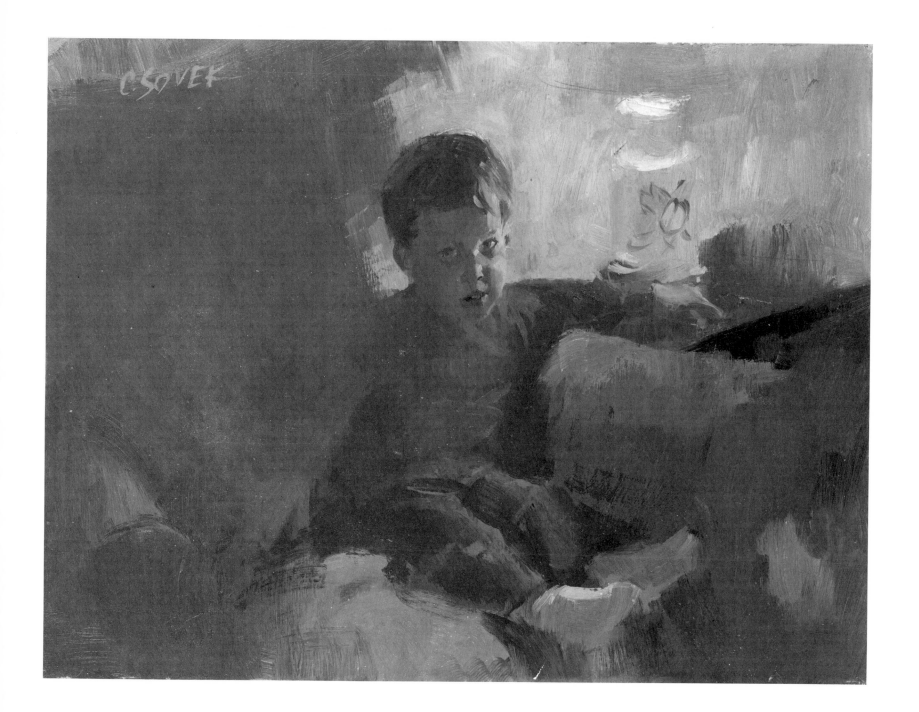

Light is what shows us how things look. Walk into a darkened room, turn on the light and suddenly the room and what it contains appears. The simplest kind of light comes from a single source. The smaller the light source the easier it is to understand. A lamp on a coffee table, for example, illuminates the objects closest to it sharply and with strong contrast. Objects placed farther away from the lamp have less contrast and definition and things farthest from the light will be hardly discernible.

Another simple example is light coming in from one window. This is most clearly seen on an overcast day when the light is soft and diffused. By thinking of the room as a box again and the light from outdoors like a large fluorescent lamp, we begin to understand how natural light works.

 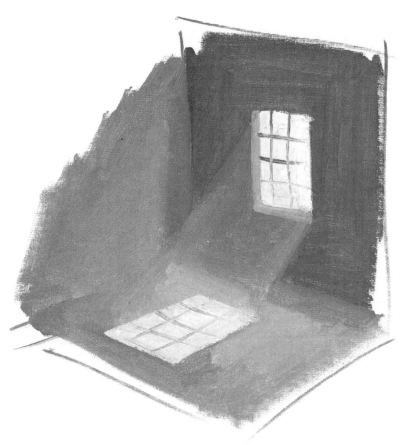

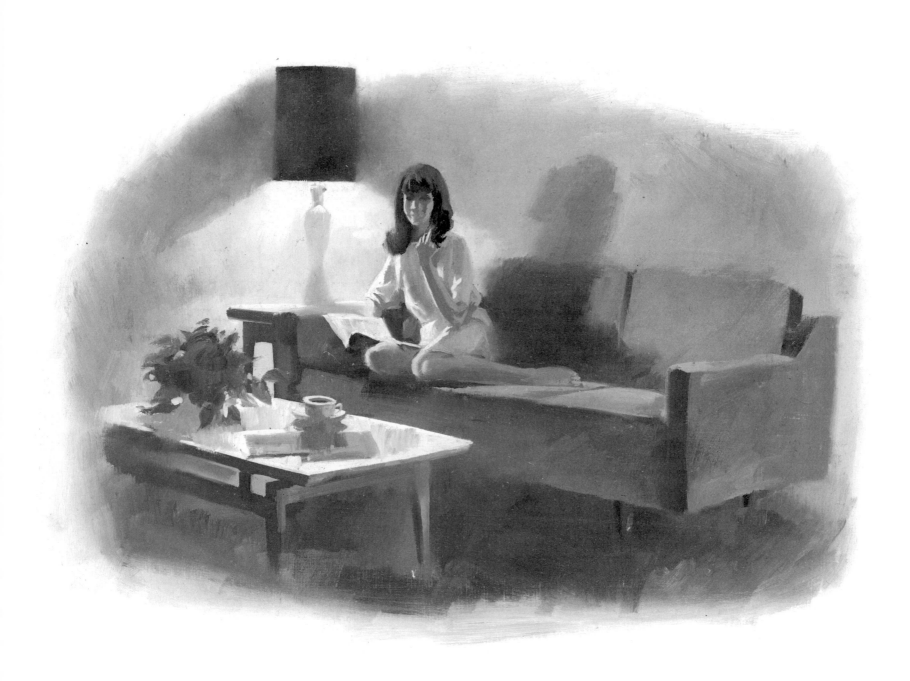

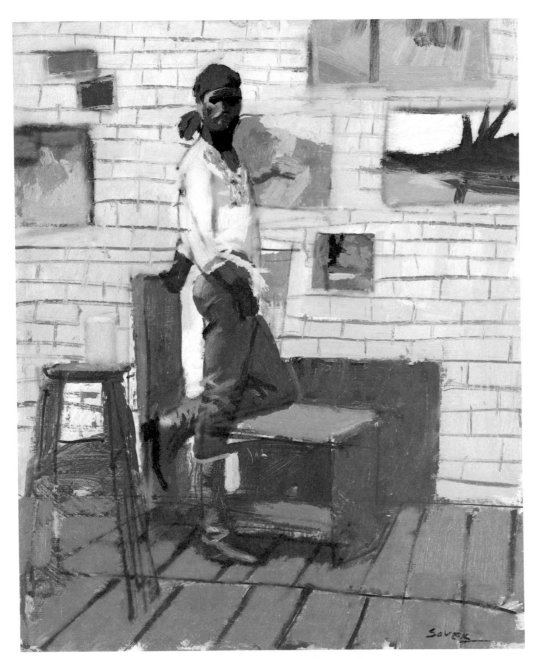

"ALPHONSE"
9x12
Acrylic and Oil on Canvas

Occasionally a terrific model shows up and
everyone in my sketch class is eager to paint him.
Whenever Alphonse is in town, I ask him to pose.
He has exotic costumes and a good sense of humor
to match. This picture was painted at night and the
light source was from a bright flourescent lamp
giving everything a hard look. I intentionally
flattened things out to take advantage of the
interesting shapes of Alphonse's outfit. The edges
are quite hard compared to my usual, softer
approach.

On a sunny day, light coming through a window is strong and direct. Painting this effect in a room tends to be more difficult because not only is there light from the sky (diffused) but the direct sunlight itself. The best way to visualize this is to imagine a room lit by a very soft, indirect fluorescent light that covers the entire ceiling. Also, mounted on the ceiling is a powerful spotlight. A sunny day has these two sources of light, and by keeping them in mind, painting sunstruck interiors will be easier to understand.

Another simple light source to paint would be from above, as in the case of a ceiling fixture or chandelier. Again, think of the room as a box so you can visualize the light more easily.

Many interior scenes are lit by more than one light source. Painting these requires careful planning. What happens when an object in a room is lit equally with two sources of light is similar to the effect camouflage has when disguising an object. The form gets broken up with so many lights and darks it becomes difficult to see.

In painting a scene with more than one light source, my experience has been to either turn one of the lights out or to paint one light source more strongly than the other. An excellent exercise to help clarify how light works is to make some small studies of different lighting situations. Keep them simple using black, white and a couple of grays. Start by making a few copies of the paintings in this book then look at your own environment and see how many various kinds of lighting you can find.

These four studies show how different light sources can effect the look of a painting. The scene is the front sitting room at the Salmagundi Club, an old established art club on Fifth Avenue in New York. How I did the painting is fully explained and demonstrated in Chapter 9. The light that originally intrigued me was the small table lamp which was bravely attempting to light the whole room. Notice how the mood changes when sunlight shines into the room. From pensive, the mood now turns cheerful, light and airy. Light like this reminds me of Sunday newspapers and fresh flowers. In the third picture, a quiet end of the day mood prevails. To me, this picture looks tranquil. Finally, in picture four, we eliminate a light source and exploit the rich pattern of values and textures. This creates still another kind of mood with the emphasis on the decorative objects and the design of the room itself.

Equally important in giving the illusion of light in a picture is the way you handle edges. Hold your hand in front of you, focusing sharply on your thumb. Notice how everything in back and on both sides of your thumb look soft and slightly out of focus. This is the quality you want to get into your pictures. A variety of hard and soft edges are essential for an interesting painting.

First they create atmosphere, giving the painting the look of actually having air in it. Vermeer was a master of this and a great deal can be learned about painting hard and soft edges by studying his work.

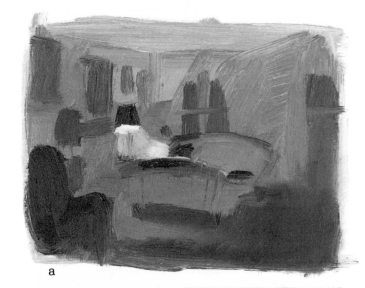

a

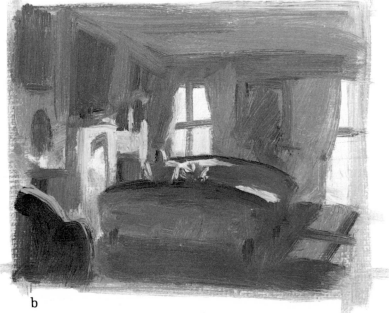

b

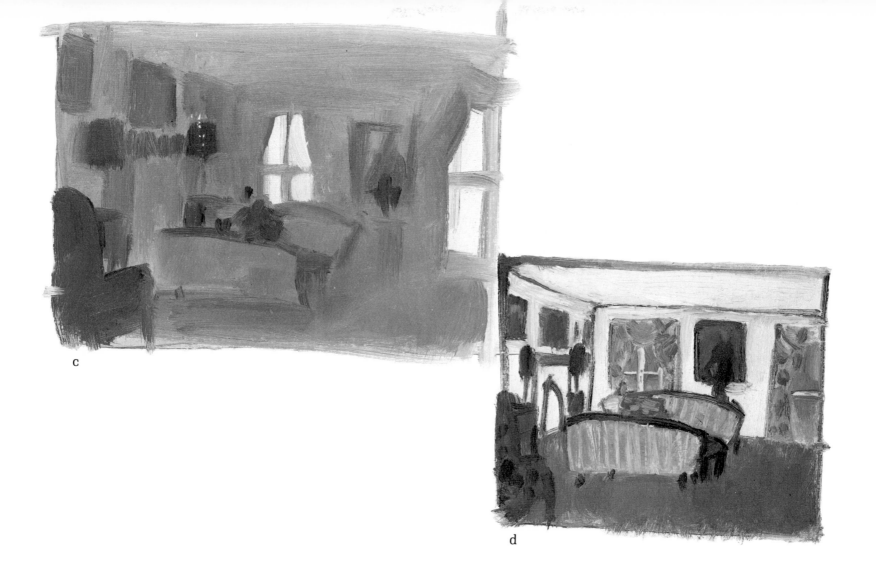

c

d

The other quality edge control gives is to help us focus on a center of interest. Reserve the hardest edges and strongest contrast for that area.

To learn how to soften edges, choose the medium you have most control over. Oils are ideal because they stay wet longer. I happen to like the way acrylics can be softened, however you have to work fast because the paint dries quickly, but with practice it can be done. Pastel is probably the easiest to soften using either your finger or a soft cloth. Be careful, however, not to soften things too much or you'll get a mushy quality where everything looks like it is made of mayonnaise.

"FRESCA"
16x20 Acrylic on Illustration Board

Looking from one room into another can make an interesting composition. The nearer room almost frames the far one. Observe how I've softened many edges in shadow and have indicated rather than rendered the pattern on the nearest wall.

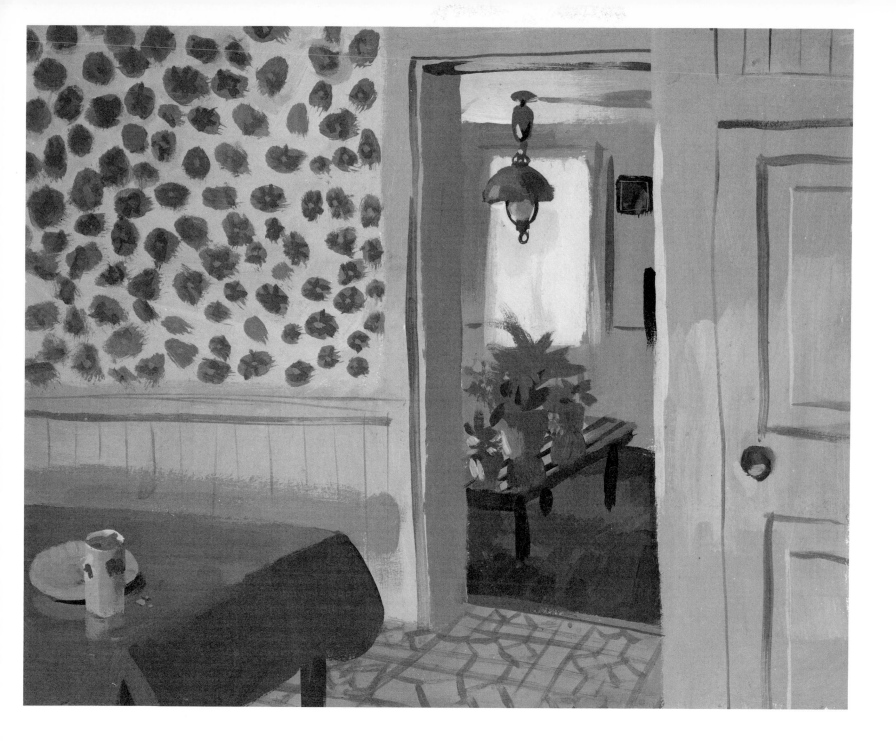

Pencil and charcoal are also fairly easy to soften. Watercolor and pen and ink are probably the hardest. Watercolor, because it dries lighter than when wet, can look overworked if not properly handled.

Softening your edges in pen and ink is difficult because of the great number of lines needed to create a tone. Unless you've had a lot of experience with pen and ink, try a more familiar medium for this problem. Once mastery is achieved, however, some beautifully soft, atmospheric effects can be achieved. Joseph Clement Coll, illustrator of the 20's, worked exclusively in pen and ink and was a magician at getting the effect of atmosphere and mood into his pictures.

The technique of softening an edge is about the same with all the opaque mediums (oil, acrylic, opaque watercolor). Lay in, side-by-side, the two values to be softened. Swish out your brush and with either your finger or a paper towel, wipe out most of the water or turps. Using a zig-zag motion, wipe across both values. Swish out your brush and again wipe out most of the water or turps, and with a single stroke, wipe over the zig-zag strokes. The slight moisture in the brush will blend the paint forming a clean, soft edge. The degree of softness depends on how wide you make the zig-zags.

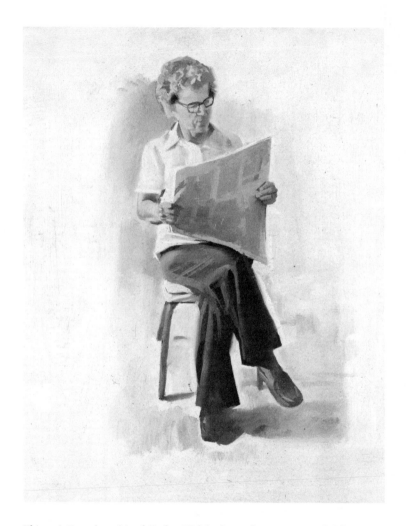

This painting of my friend Evelyn Welch shows the treatment of different kinds of edges. They range from hard, the pants and shoes against the background, to slightly softened, the shirt on the right side of the figure against the background. Softer yet is the treatment of the hair and flesh, and softest of all is the indication of the words printed on the newspaper and the light values which surround the figure giving it a background. Edge awareness like this will give your painting a more three dimensional, believable look.

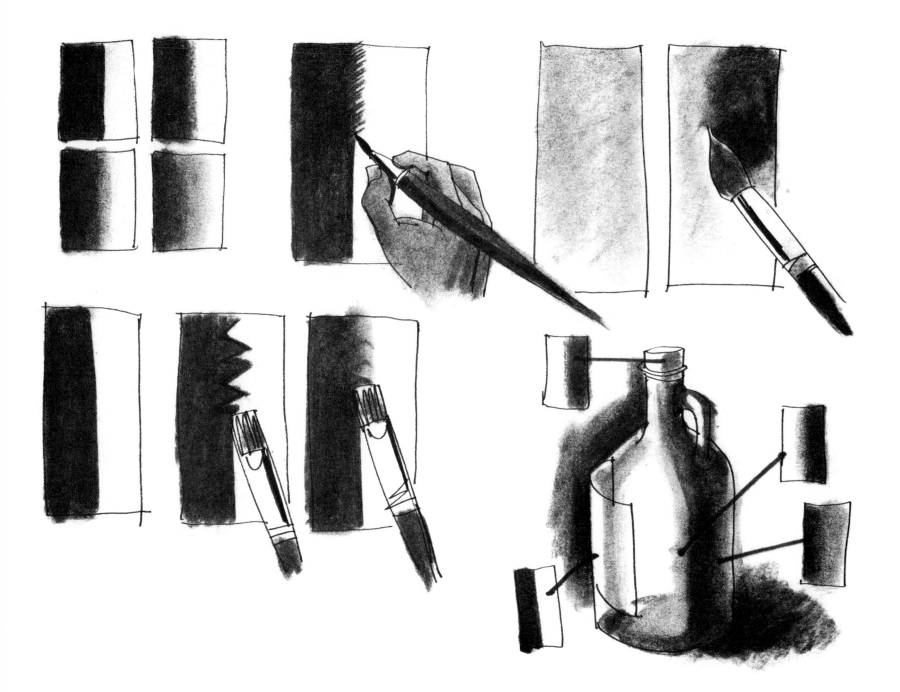

Once aware of edges, your painting will take on many new dimensions. To a large extent good painting depends on your ability to handle values and edges.

Although a lot of atmosphere can be achieved with a soft treatment of edges, there are some subjects which require hard edges. Some softening of edges is necessary, but by comparison to the softer picture, the overall painting will look hard.

Modern interiors seem to look better this way. Strongly lit subjects will also lend themselves to a harder treatment. Decorative paintings often hold together better when the edges are hard and defined.

Edges can be classified into various kinds. Starting with the softest, let's consider the light from a candle or a small nightlight. The edges here will be soft and almost a blur. Then there are the edges of soft objects like hair, fur or soft cloth. These should be softened so there's a lost and found quality to the forms. Next, we have the edge where similar values appear

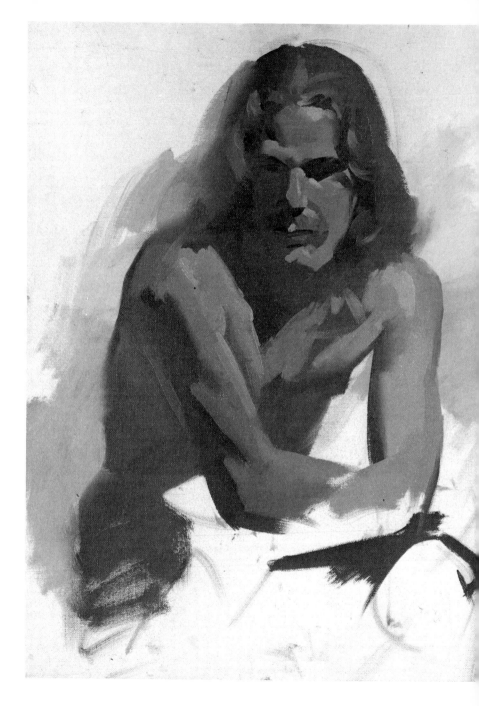

Soft edges predominate this painting. Observe how the shadow of the face and neck almost disappear and the hair merges into the background.

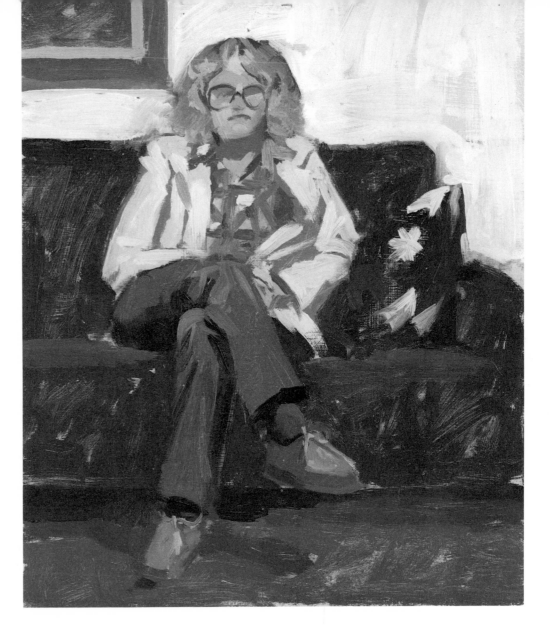

"SUE"
 10x14 Oil On Panel

The treatment here is much harder. Sometimes a pose will dictate how the edges should be handled. The model is one of my students, Sue North. She hadn't had dinner yet, maybe that's why she's so solemn. The scene called for crisp, hard edges with only a few soft one's to show contrast.

beside each other. Wiping these together will add atmosphere to a painting. Where two forms meet, soften the one least important to you and your picture idea. Another place where edges can be softened is as objects go back into your picture. This is particularly effective when showing a whole room and you want to give the illusion of deep space. The farther away an object is, the softer the edges appear.

Finally, there are the edges you soften intuitively. Here you put aside rules and principles and rely on your visual instinct. Since we all see things differently, it is important to trust yourself when an area in your painting seems to need softening. It may not fit into any of the rules, but that's O.K. The personal quality you get into your pictures is more important than any axiom.

This intuitive quality will also keep your work fresh and alive. Not knowing how a picture will finally come out can create a sense of adventure. When I mentioned earlier about painting being as exhilarating as a mountain climb, it's this area of the unexplored that offers challenge and intrigue. That blank white canvas in front of you may end up with something beautiful on it if you trust yourself to paint the way you *feel* it can be done best.

"SATURDAY'S WORK"
16x20 Oil on Canvas

The straw and reeds are waiting to be woven into something. Story-telling pictures can be fun so long as they don't become trite and suffer as paintings. I found this corner fascinating. The low light and soft, mysterious edges are all qualities I like to paint. The shadows are handled rather thinly while the light areas are built up thickly in places, especially in the window.

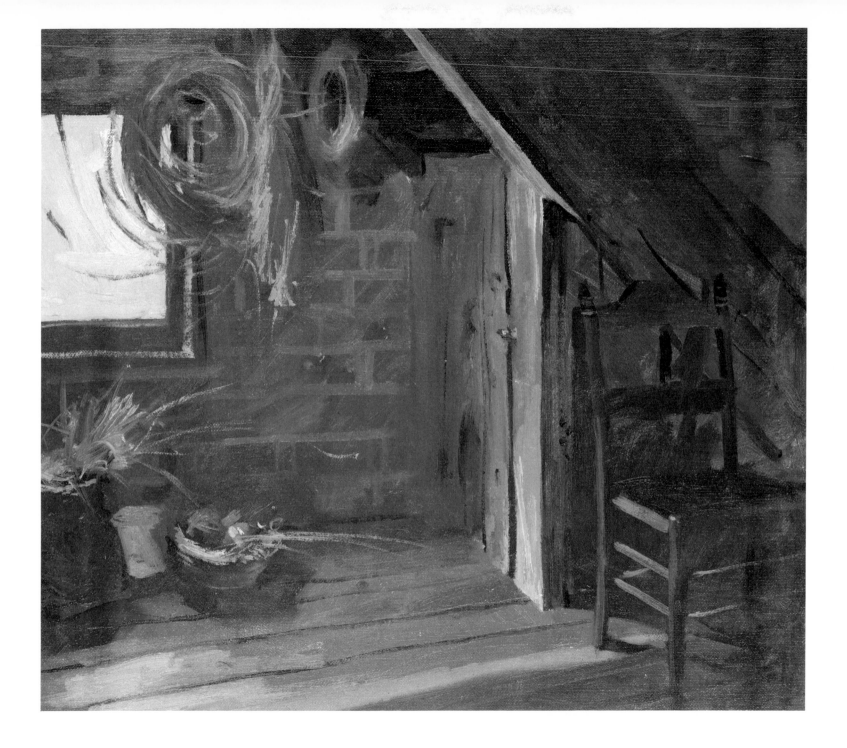

CHAPTER 5
Combining Interior and Exterior

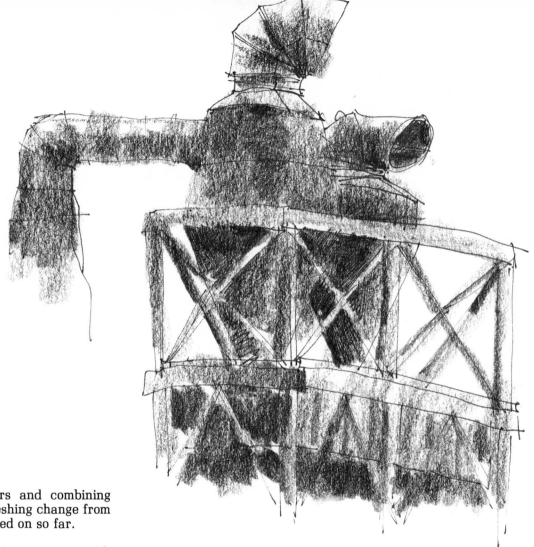

"SMOKESTACKS"
9x12 Pen and Conte Crayon on Paper

Painting outdoor pictures from indoors and combining interior with exterior scenes can be a refreshing change from the strictly indoor scenes we've concentrated on so far.

Two ways I've found successful in combining interior with exterior is to focus attention on either one or the other, giving us a built-in center of interest each way. This can be accomplished in a couple of different ways. Adjusting our values is one way. Hard and soft edge control another.

The problem in painting many indoor-outdoor scenes is that the value range is so great, and you can't possibly match what we see with paint. Remember holding up the white paper with the black square on it to the light? You must adjust your values if you hope to make your picture believable.

I was looking out a window of my car when I did these drawings. You could say I was indoors but not in the conventional way. An automobile can be an excellent portable studio. Granted, you can't work much larger than 12x16, but for small drawings and studies, it's a fine way to beat the weather. It also solves the bothersome onlooker problem. The shapes of the industrial smokestacks are what prompted me to make these drawings, and the more I looked at them, the more my imagination was stretched. They could be judges, critics, or even wisemen. I wonder what a child would see in them?

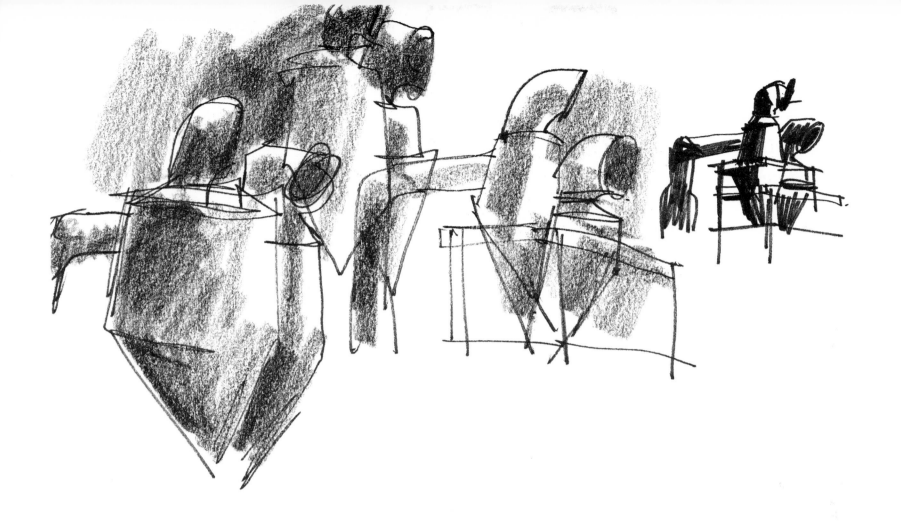

The paintings on these pages are examples of solving this problem two different ways. The window scene overlooking Rockport Harbor places attention on what's out the window and minimizes the objects inside. The back porch interior gives attention to the objects on the shelves while lightening and simplifying what's out the window. In both paintings the values out the window are light, avoiding any gray or black accents. The harbor scene with all the boats, buildings and piers is very light in value. To go darker would destroy the illusion of outside light. The effect is much like looking at a picture on a television set. The picture tube is light even when showing a night scene, when compared to the furniture and the surrounding room.

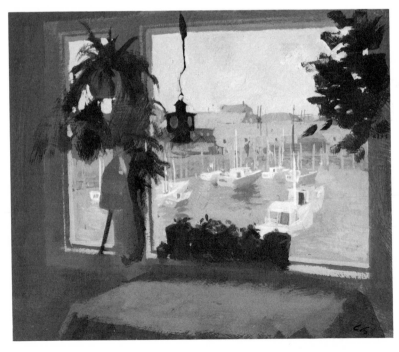

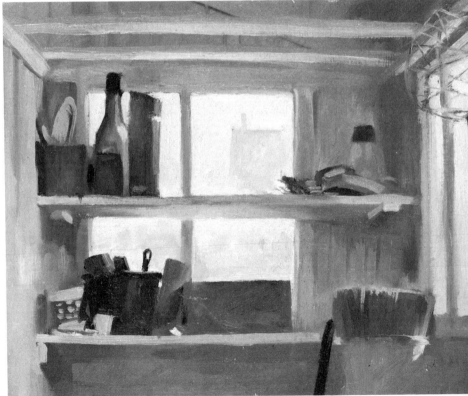

These sketches were drawn with a ball point pen on scratch paper looking out the window onto Rockport Harbor. They took no more than 15 minutes, and proved useful months later when I painted the scene.

REFLECTIONS

DARKS GET LIGHTER

LIGHTS GET DARKER

REFLECTIONS.

GO TO INFINITY

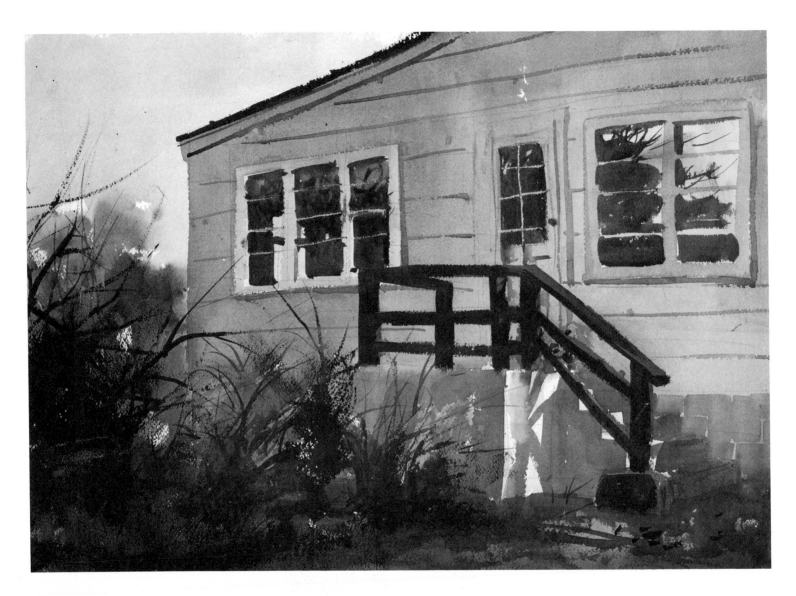

"BACKSTEPS"
16x22 Watercolor

Though the sun is bright and the sky cheerful, you can see by the bare branches on the trees that it wasn't summer. It was November and about 25 degrees outdoors. I sat in a warm comfortable kitchen painting this picture which was the view directly out one of the windows. Some speed was still required due to the fast moving sun. It took about an hour and a half to complete.

76

Another picture possibility at your disposal is painting outdoor scenes through your windows. There is a wealth of material available and in all weather conditions. Although nothing can quite compare to being outdoors painting on a warm, sunny day, equally interesting pictures can be found on wintery, overcast days. To me, some of nature's most interesting moods are rainy days and winter afternoons when it's snowing and the sky has just enough color to illuminate the landscape. Such conditions usually don't last long and you must paint quickly. I've painted outdoors on days like that and will probably do it again, but baby, it's cold and the working conditions miserable. Many of these problems can be eliminated by working indoors, looking outdoors. Winslow Homer built a portable studio on tracks that could be wheeled down to the ocean's edge where he could observe and paint the rugged Maine seacoast. Camile Pissarro would work in a hotel room overlooking the busy Paris streets at night and record the shimmering effects of light. Renoir, also working from a hotel room, is known to have recruited his brother to scurry outside and engage passers-by in brief conversation while the artist furiously painted the figure into his composition!

Often I've heard the complaint, "There's nothing interesting to paint where I live" or "If only I could go to a picturesque place to paint." What I think many of these people are really saying is, take me to a place that's been painted by other artists so I don't have to be original and my work will look a little like so and so's and thereby be accepted. No problems, no struggle, nice and safe. And nice and boring as well. Have you ever heard a child ask to be taken to Rockport or Spain or San Francisco because there was more there to work with?

I can't believe there's a view from a window anywhere that doesn't offer something to paint. For starters, there's your changing environment both seasonally and architecturally. Claude Monet, with his many paintings of churches and haystacks under varied lighting conditions opened doors for all painters to the possibilities available to them. Cezanne also showed how multiple pictures of the same scene can be worthwhile and exciting.

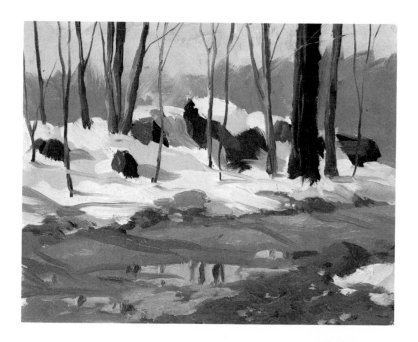

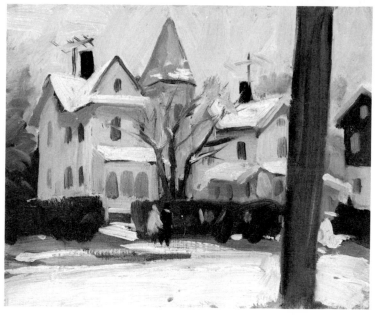

A painted record of the changing seasons and weather conditions out your window can be a fascinating study. A couple of pieces of ivy growing on a brick wall, or just the brick wall itself is subject to changes in weather and lighting conditions. Look what Andrew Wyeth has done with simple everyday scenes that most people would walk by without ever recognizing the picture possibilities.

Over the years man-made environments change and one of these days, that dilapidated old garage you've looked at ever since you can remember might not be there. By drawing or painting it, you'll have a permanent record of something that won't ever be built like that again along with the memories that go with it. When I lived in New York City, I could see out my window many other windows, each one of them different—roof tops, watertanks, chimneys, skylines, poles, signs and miles of telephone wires with birds sitting on them. All this was compounded by changing seasons and weather conditions. It was noisy, busy and not very clean and that's the way I painted it. Now that I live in the country, those paintings mean a lot to me, not only as a record of where I once lived which has already changed, but memories, both good and bad, of a part of my life.

Think of your geographic location as special. You live there, see it as a unique place. By painting your environment sincerely and honestly, you'll also find less of a need to travel to some faraway place to paint. Believe me, there are pictures just outside your window.

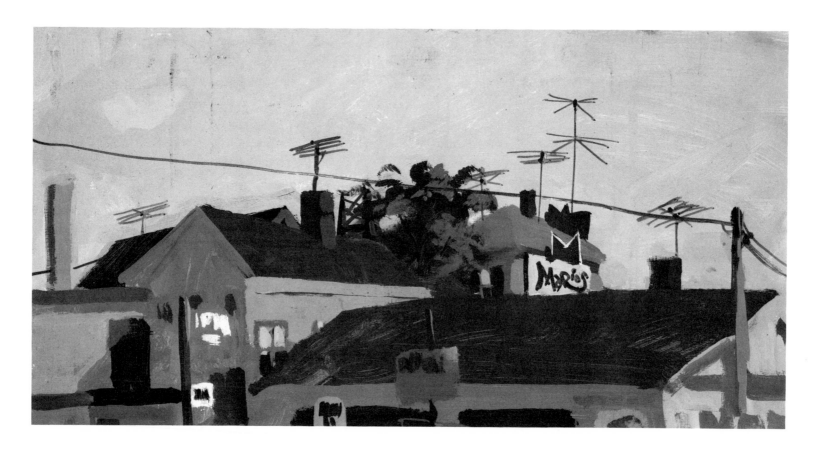

"MARIO'S"
 Acrylic on Panel

An old studio I once rented faced some interesting old rooftops in Westport. One day the light looked so good, I couldn't resist. Rooftop pictures have a special quality to them. Edward Hopper has done some real masterpieces. This was my first one and I'm looking forward to doing more.

CHAPTER 6
Color

Of all the areas of expression in painting, color probably has the most flexibility for bending to the artist's particular needs and personality. As a teacher, I find color causes many students a lot of unnecessary trouble. Usually it's because they're trying so hard to paint *exactly* what they see that they have little fun and the results usually end up uninspired. This need not be the case. Color is something sensuous—use it to satisfy your personal needs. Artists didn't always have such freedom; tradition applied many inhibitions. Before the Impressionists, the use of more than a hint of bright color was thought of as blatant, if not downright sinful. Most paintings before 1850 were built on drawing and values; color was an accessory. Some of this may have been due to the lack of tube colors that were available before the later part of the 19th century. The earth colors, black, red and one blue were about the only permanent colors available and they had to be laboriously ground by hand. Working within these limitations, however, a great number of excellent paintings were created.

To put the color revolution brought about by the Impressionists into perspective you must go back a few centuries and study the development of realistic painting.

Titian was one of the first artists to use values and hard and soft edge control in his paintings. There's a quiet quality of existence to Titian's paintings, especially when compared with many of the other painters of his day. Most paintings were really toned drawings. Rembrandt carried the concept further by building up the paint in the light areas of his pictures, giving them a rich textural effect. There was still relatively little use of color, but painters like Rembrandt, Franz Hals, and later Velasquez, were wizards at creating colorful illusions of what they painted. Vermeer was one of the first artists to paint objects the way they actually appeared to the human eye. His light-filled corners of rooms, with their cool ultramarines and grayed lemon yellows, caught perfectly the pearly quality of the moist light of his Holland homeland.

With the innovation of putting paint in tubes, about 1850 by Messrs. Winsor and Newton, came a flood of newly developed colors quite revolutionary to painting. These included mauves, violets, roses, sap greens, warm and cool reds, a variety of oranges and yellows. Unfortunately, in their eagerness to supply the artists with new colors, many of the manufacturers neglected to make their products permanent. Sadly, some of the finest early Impressionist paintings have faded considerably. The doors were open, however, and a new light was shining. Light with color abounded. To many it was disgraceful and obscene. To the young painters who were fed up with "brown sauce pictures" it was a whole new way of seeing. Before going on to analyze what these adventurous young painters did, let's discuss some of the principles important to understand for the successful control of color in painting.

"QUIET AFTERNOON"
9x12 Acrylic

The quality of light that comes in a window on an overcast day is fascinating. The mood is usually one of stillness and peace. The small child asleep in the rocker adds to the mood. There's a lot of glazing in this painting. When I indicated the wallpaper pattern, it looked much too important. As soon as it dried I washed over a rich glaze of Burnt Sienna thinned with water and the pattern receded to just the proper degree of importance. Acrylics are an ideal medium for this type of painting.

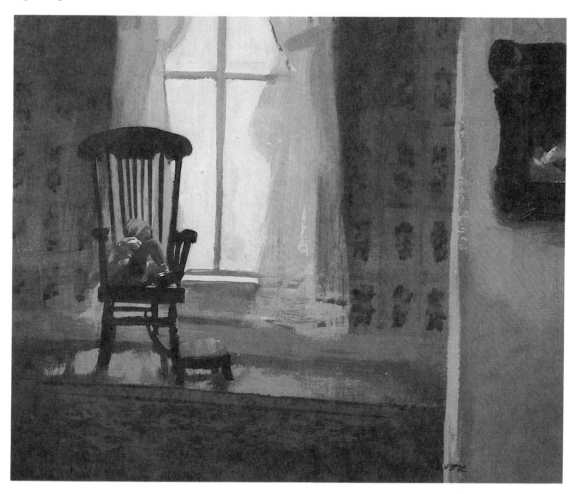

Any color that comes from a tube has three basic properties, its COLOR, like red, blue, yellow or green. Its VALUE which is its lightness or darkness. Yellow from the tube is light, orange medium and blue usually dark. Imagine a black and white photograph of these colors and you have the idea of a color's value. The third property is INTENSITY. This means a color's brightness or dullness. To understand this, look around you, probably only a few objects are pure color. Walls and ceilings in homes are seldom painted with pure color, usually the color is subdued and in some cases almost a gray. A fresh yellow daisy or a red rose usually stands out in a room for this reason. The flower's colors are HIGH INTENSITY, the walls and ceilings of the room LOW INTENSITY. Try to clearly understand this for the language of color is built on these three principles.

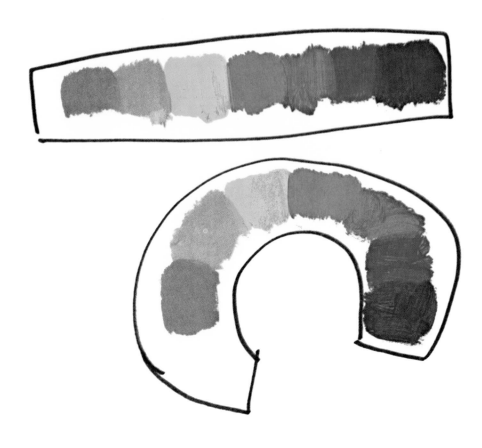

Nature has given us a ready-made palette in the form of the spectrum. Hold a prism up to direct sunlight—the colors it reflects onto the nearby wall are a treat to the eye. Starting with violet, you'll see indigo, blue, green, yellow, orange and red. An easy way to understand the spectrum colors is to imagine bending the straight line of colors into a circle. By matching the colors of the spectrum with the pigment of paint colors and laying these out in a circle, we have the traditional color wheel.

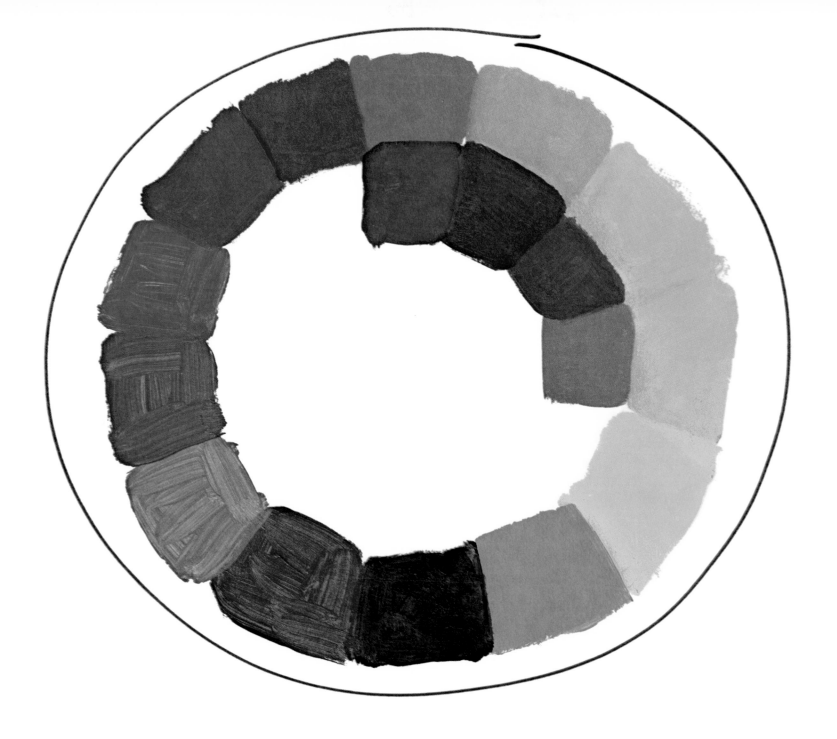

Another property of color is its warmth or coolness. The color wheel can help us in seeing not only the warm and cool sides to the color wheel, but warm and cool versions within each side of the wheel. Cobalt blue, for example, is generally considered a true blue. By comparison, cerulean blue would be warm, leaning toward green and yellow, where ultramarine would be cool leaning toward purple, yet these are all blues and on the cool side of the color wheel. Cadmium yellow medium is warm because of the orange in it, cadmium yellow light is about in the middle, and cadmium yellow pale or lemon yellow would be considered cool leaning toward green and blue. Alizarin crimson would be cool leaning toward blue, cadmium red medium about in center, and cadmium red light warm leaning toward orange.

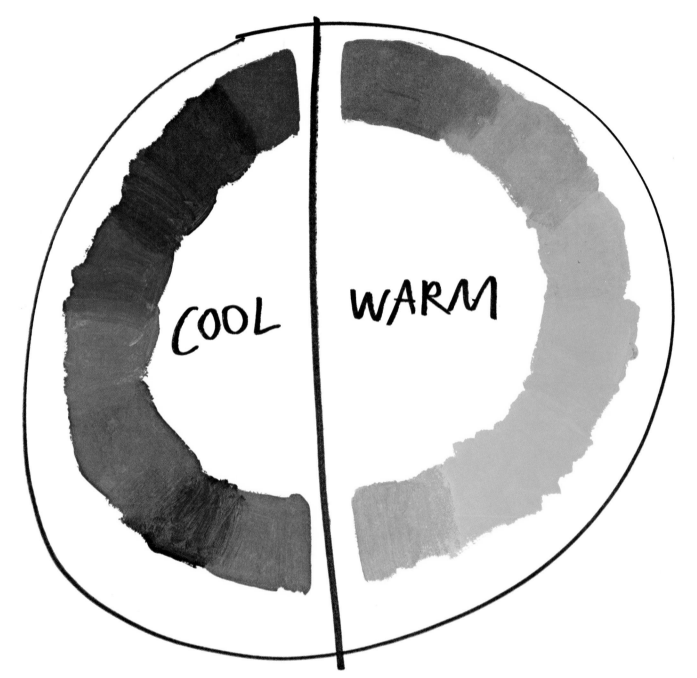

At first this may all seem confusing, it did to me. By experimenting on your palette and seeing these warms and cools occur, the idea will soon become clear. The key to it all is *relationship*. Colors can be warm, cool, light, dark, bright or dull only in *relation* to what they are associated with. One color in one environment could appear bright and warm. The same color in a different environment might seem dull and cool.

We're fortunate living at this point in history—we have all the painting of the past at our disposal. There's not only the sparkling color qualitites of the French Impressionists to draw from, but the rich tonal schemes used by the painters before them. You may, at times, want to combine these two methods. To do so correctly, you must understand clearly how color and values relate. In the demonstration on this page, I've used the five values we worked with in Chapter 3. Each color as it comes from the tube, is placed beside its closest black and white value. My aim is to show the lightness or darkness each color is before it's mixed with white, black or another color. It's important to understand the value of color while painting. The two pictures looking out the windows on page 74 are effective because of value-color control. The areas out the window were painted light in value and all the color mixing was done in that value range. The interior part of the paintings were much lower in value, and the colors used were also dark in value. Everyone who plays a musical instrument knows about musical scales. In painting, it's just as important to know and practice your value scale.

This chart shows what VALUE some of the colors are just as they come out of the tube. Notice how light yellow is. To darken the value, add yellow ochre or burnt umber. By contrast the blues are quite dark and, interestingly, when a little white is added, they get even brighter as well as lighter. To make the dark valued colors lighter, white usually does the job. To darken the middle colors, add black until you get some experience with dark valued complements. Controlling the value of a color is most important.

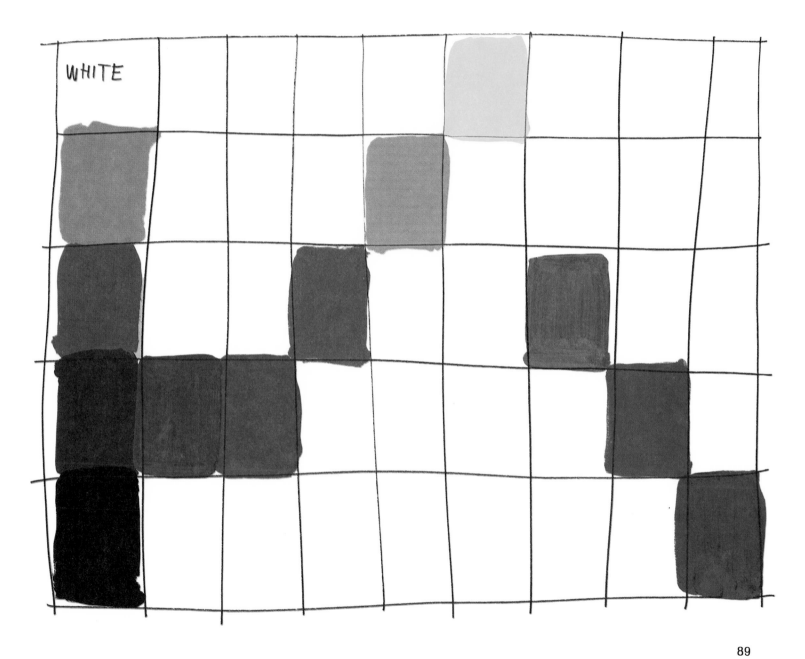

WHITE

Grays are easy you might say. Just mix black and white as light or dark as needed. Simple as one-two-three. There are painters who do just that. Usually those painters have had lots of experience with color and can mix grays using only black and white with impressive results. The method most widely used, however, is to mix grays from colors. The principle is simple enough. Look at the color wheel and choose any two colors opposite each other on the wheel. These colors we call complements. Red and green, for example, or blue and orange or yellow and purple. Our aim here is to mix a gray, but more than a gray, a gray with color. By doing this exercise on your palette, it will be clearly seen how the grays "hint" at being a color while giving a quality and mystery to the gray not found in straight mixtures of black and white. What's more, every set of complements will yield a different kind of gray. You may want to add some white to the darker colors like blue and green so they don't overpower the lighter colors. One last word about grays, considering light as having color (warm table lamp, cool window light, cool greenish fluorescent), even gray objects will take on some of that color. Painting these subtle grays can give your painting great quality not found when the artist was unaware of these grays. I like to think of grays much like a chef thinks of sauces and gravies. A dinner can be satisfactory without them but with them, Voila!

Whatever medium you choose your palette can be set up much the same way. As shown earlier, when nature gave us the spectrum it also showed us a way of setting up a palette. Some painters, watercolorists in particular, actually use a round palette and squeeze out their colors in the same order as the color wheel. Another way, and the way I've found most successful, is to start with purple, then going to cold and warm red, orange, yellows, green and finally warm and cool blue, which puts me back where I started completing the wheel. I think every painter has his or her pet way of laying out colors. Watercolorist John Pike puts his blue and green on the left, red and yellow on top, and earth colors on the right. Jack Pellew lays out his acrylic palette with burnt umber first, goes through cerulean blue, thalo blue, burnt sienna, cadmium red light, alizaren crimson, cadmium orange, raw sienna, yellow oxide and azo yellow medium. Portrait painter Ray Kinstler's oil palette goes from black, working clockwise through the dark valued colors to the lightest. All of these men have developed these palette arrangements through trial and error. My own palette, shown on this page, is much the same way it looked 20 years ago. I've experimented with dozens of variations only to go back to an arrangement I can remember writing on the back of a piece of illustration board in my first year at Art Center School in California. To keep from getting into a rut, however, I'll occasionally react to a scene strictly on impulse and squeeze out my colors accordingly. By concentrating only on the scene in front of me my palette grows according to the colors I see and not in any pre-arranged order.

Claude Monet said he wished he could forget everything he ever learned each time he went out to paint so the scene in front of him would be viewed as a one time occurrence. Because Monet learned the rules in the beginning, he was able to approach nature with this childlike freshness.

The best and fastest way to learn about color is to paint. I encourage my students to start with simple, unglamorous set-ups. The studies on this page are typical examples. These pictures were not painted for their innate beauty of the subject, but because the shapes they made and the light shining on them was interesting to me.

Go to your cupboard or workshop and choose a couple of objects that look interesting to you. Try to choose things you might not have considered as paintable material. Avoid the oriental vases, statues, open books and flowers. Many of these objects are truly beautiful and I think painting fresh flowers can be a sheer delight. Why, then, not paint these picturesque objects? Why make things difficult? For the very reason that they are picturesque and have been painted hundreds of times by artists, we've become used to looking at such subjects in a certain way. A solution is to paint a couple of unglamorous objects in a still life arrangement. This will force you to provide the beauty and not rely on the objects.

Learning to see interesting value arrangements and colors no matter what the subject, is the real idea behind painting. By realizing that it's possible to paint a masterpiece from a side of beef (Rembrandt did) as well as paint a failure from a beautiful vase and flowers will set you on the road to painting good pictures. The drawings of the sardine cans on pages 26-29 are, to me, little works of art. I've always liked my painting of the Lipton Soup box, light bulb container and film canister. The objects themselves are blah and commonplace. When painted, however, they turn into a picture.

I'm not saying throw away all your vases, flowers and urns in favor of old sardine cans. I am saying, try to see the beauty in commonplace things. Be able to paint a hammer and have it stand on its own as a painting. Then, when you do decide to paint flowers or objects beautiful in themselves you'll see them as picture material and arrange them to look well as color value and shape and not thoughtlessly copy something because it's pretty.

Now would be a good time to paint some of the things you know and care about. If you're a cook, there's a wealth of material in your kitchen. Painter Al Chadbourn, who also happens to be an excellent chef, has made many fine compositions from the pots, pans, dishes and food he uses in his cooking. If you're a camper, set up your knapsack, a hat, perhaps a map, coffee mug and some wild flowers. A boat enthusiast might choose a couple of old bouys, some rope, shells, even an old pair of sneakers. The important thing is to paint what you know and care about. Have some fun with it and you'll probably get a lot more life into your painting than if you set up that somber statue of Beethoven with a sheet of music and a quill pen. Like Schroeder, I'm also a fan of Beethoven, but I much prefer listening to his music than looking at a white bust of his head.

The paintings shown here are what I consider the basis for painting pictures indoors. I've painted dozens of these for different purposes. Some are done to catch a tricky lighting effect, or perhaps I'll see an interesting combination of objects that "click" as being just right. The following account might give you some idea of how I decide to paint a picture.

While having dinner one summer evening after a long day of painting, I was looking forward to having a leisurely second cup of coffee and a cigar. A friend of mine opened the door in the next room and as I turned my head to see her, I saw reflected on the window part of the door, a hanging flower basket and a little bit of the white gingerbread trim that adorn so many of the old homes in New England. The light was just right and the effect was beautiful, With my paints still in the car, a dialogue went on inside me something like this, "That effect is so great, I wonder if I could remember it and paint in in the studio tomorrow? I really worked hard today and deserve this leisurely after-dinner time." I was looking forward to that cigar! The light was slowly changing, the effect was about the same. I knew it would last about 15 or 20 minutes longer and then be gone.

More inner dialogue, "A quick pencil sketch might do it—where's my pencil? Look at those warms and cools!" Again, a subtle, yet definite shift in the light. What followed was a 50 yard dash to my car and back. Quickly setting up my gear I painted furiously for about 15 minutes. Then it was gone. What before was a little doorway alive with dancing light and color was now just another drab entrance to a house. The effect was gone, or was it? I like to think my painting captured an instant in time that, like a butterfly was beautiful to behold and then inexorably gone.

What prompted me to paint the scene and the inner dialogue just described is typical of the way I work. Painting can be hard and demanding, and sometimes the pictures don't come out well. The satisfaction may be in the striving.

When I was first learning to paint, most of my efforts didn't turn out well. With practice it gets to be about half and half. If you really work hard, you might get lucky and hit two out of three successfully. Is it worth it? I think it is, but you'll have to answer for yourself.

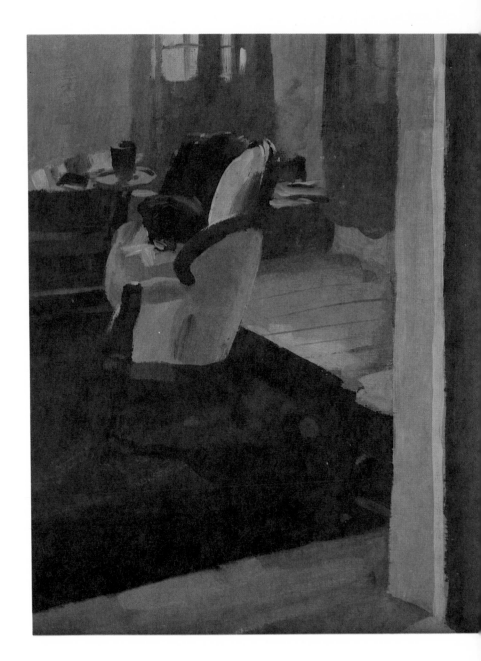

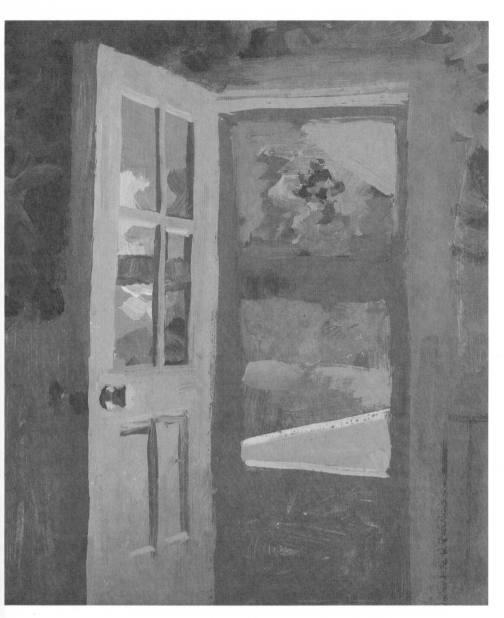

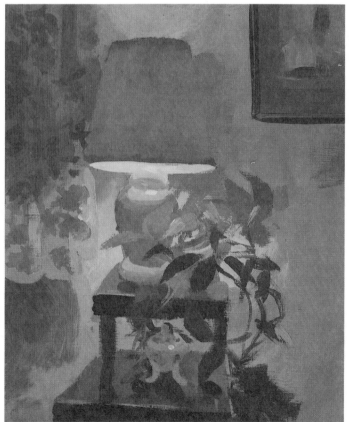

I like to put dates on the back of the color sketches. When I get discouraged after a couple of flops I can look back and usually see there has been some growth and improvement despite my immediate difficulties.

Painting people into your indoor paintings is not as difficult as you might imagine. Chapter 7 will deal more thoroughly with drawing and painting people. However, while we're concentrating on color let's briefly consider some color aspects of painting people. When you start to draw and paint figures, try not to think of them as something different from what we've been doing with interiors and still life set-ups. The same problems exist with light and shadow, hard and soft treatment of edges, and of course, color. The latter is probably the toughest to represent. You can be a little off on the color of a rhododendrum and few people will notice. Be a little off on the color of somebody's forehead, however, and it's very obvious. This shouldn't frighten you. We all go through it, and with some practice, painting people will be another challenging option in your what-to-paint kit. I find a sketch class most useful for developing figure drawing and painting abilities. The paintings on this page were all done from either models or friends who posed in my studio for just such a class. There's something stimulating about working with artists. Some painters prefer to work alone. Try both.

If you've never drawn or painted a figure, it's best to start with short five or ten minute poses. Work for the gesture which is what the person is doing. Some of the drawings shown here were done quickly, in some cases with the model moving as I was drawing. It's always surprising to me how little you need in a drawing for it to look finished. Another excellent way to develop drawing skills is to carry a sketch book with you, developing your own kind of shorthand in recording the activities around you.

Television can be another source for models. Though the images won't stand still long, there are lots of close-ups, especially on talk shows. The drawing of George Plimpton was done while watching a talk show, and the country-western singers while watching a special.

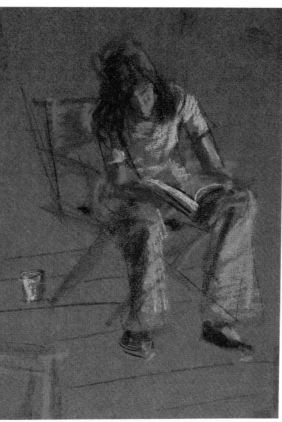

GEO.
PLIMPTON

99

Why bother? Why not get someone to comfortably pose and draw what you see? That's fine and should be done when a precise study is desired. However, the drawings of the country-western singers were done rapidly, while the performers were constantly moving. The gestures and the action were the very thing that inspired me to draw. By doing so I came away with a new awareness of this kind of group, how they look, move and relate to each other. At some future point, I might see someone playing a guitar and ask them to pose for me. Having drawn these country-western performers I'll know a little bit more about posing a musician and what gesture might add a spark of life to give me a better painting.

When doing people don't separate drawing from painting. You can draw just as incisively with a brush as when you have a hard pencil in your hand. A pencil, too, can yield almost painterly results. If you find yourself getting too serious and tight, switch to some quick sketches holding the pencil or charcoal at arm's length and draw with the motion of your arm rather than tightly holding the pencil. Not being a "quick starter" myself, I find a couple of minutes of fast sketches excellent eye-openers for longer, more sustained studies.

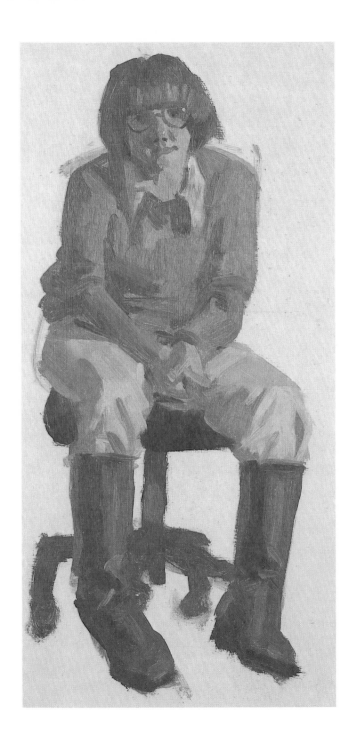

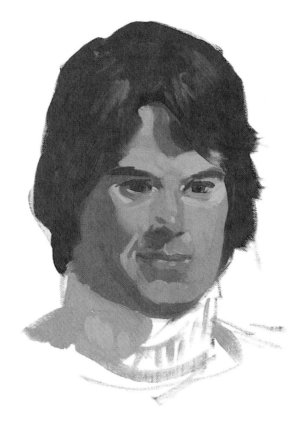

One way to learn to paint people is to work small. Draw directly with a brush and lay in the light and dark values. This method forces you to PAINT. If you make too detailed a preliminary drawing there is the temptation to thinly fill in the lines with paint. Trust yourself and start directly with a brush. Looking for the large, simple masses and lay them in boldly and simply. The first dozen or so of these paint sketches shouldn't be carried too far. John Singer Sargent would paint fast two and three hour paint sketches of his friends. When some of these were dry, he would paint another one on top and perhaps a third on top of that one! He used them as exercises to train his eye. Few of Sargent's sketches have survived. The sketches on this page were done in the same direct manner.

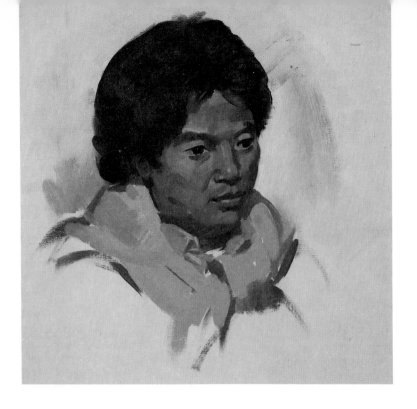

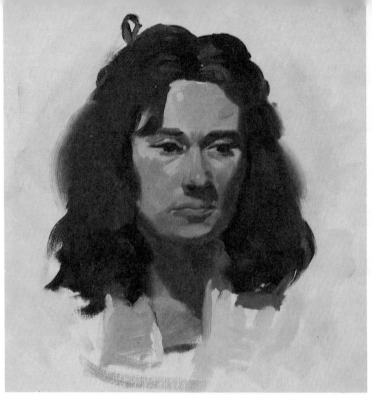

"TONY HO"

The flesh tones used were made from mixtures of Cadmium Yellow Light, Yellow Ochre, Burnt Sienna, Permanent Green Light and Ultramarine. The dark hair was mixed with Ultramarine and Burnt Umber.

"CARLA"

Alizarin Crimson, Yellow Ochre, Cadmium Red Light and Cerulean Blue, gave me all I needed to match Carla's complexion. The cool shadow areas around the eyes were made from Yellow Ochre, Alizarin Crimson and a small amount of Cerulean Blue.

Not only does a person's complexion vary with ethnic differences, but each race has many variations within it. I've always enjoyed painting people and trying to capture their particular complexions has proved endlessly fascinating. A few spots of the right colors on the head will give a surprising likeness of a person even before the features are indicated. To paint this way you must learn to see and simplify. Many artists have little crow's feet at the corners of their eyes. Most people think this is caused by the artist being such a happy person and he's always smiling. This would be a nice story if it were true,

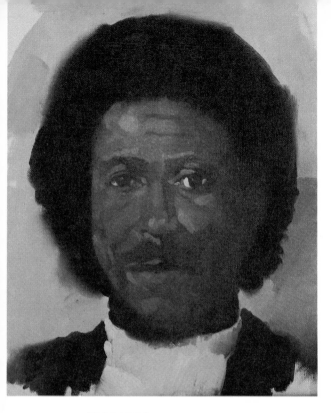

"ROBARD"

The dark flesh tones used here were made from mixtures of Burnt Umber, Ultramarine, Burnt Sienna, Alizarin Crimson and a little white by mixing these without the white the darkest darks are obtained.

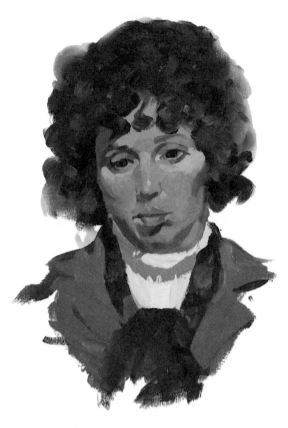

"BARBARA"

Alizarin Crimson was mixed with white to match some of the rosey color on Barbara's cheeks. The rest of the face was painted with mixtures of Yellow Ochre, Alizarin Crimson, Permanent Green Light and White. Burnt Sienna, Cadmium Orange and Permanent Green Light were the colors used to paint the hair.

"JOAN"

The colors used for Joan's blonde hair and complexion were Yellow Ochre, Cadmium Red Light, Cadmium Yellow Light and White. The shadows contain the same colors except for less White and some Cerulean Blue to cool the colors. The hair is Yellow Ochre, Permanent Green Light and Burnt Sienna lightened with White.

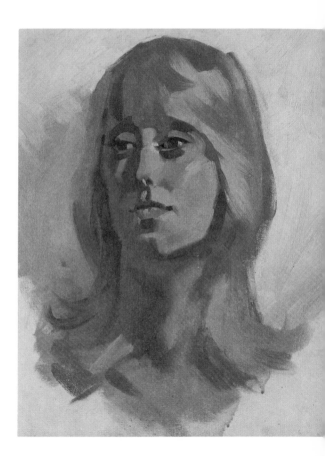

but the real reason artists have those crow's feet is because they're always squinting their eyes to see the picture possibilities in front of them. Squinting eliminates a lot of detail and enables you to see the large masses of value and color. There are other ways as well—looking through a piece of colored glass or a colored photographic filter (amber seems to work best) but this eliminates the color.

103

This ability to see in simple terms, is the real key to painting people. It frees you from slavishly copying the features of the face and let's you see the head as a whole. When I do portrait demonstrations, people are amazed that I don't paint the features of the head until the last 20 minutes or so. The first hour and a half is devoted to laying in large, simple masses of just the right color and value. Into these I'll paint the planes of the head, much like a sculptor would do his preliminary carving. When this is accomplished, along with capturing the particular color qualities of the sitter I'm then ready for the features. Approached this way, the portrait is truly a portrait of the person and not just a copy of his or her features.

What the person is doing can have a lot to do with the success of your painting. I happen to favor people in natural, relaxed poses. Somebody slouched down in a chair reading a paperback book can be a very exciting mass of shapes and colors. Usually if someone is engaged in an activity they are likely to be interesting to paint. Try to avoid the posed look. The main thing is to get the subject to relax. I usually ask people posing for me to try a couple of gestures they feel comfortable making. If these poses look stiff I'll then suggest something else. If that doesn't work, I'll then tell them to relax and take a break and this is when the best poses of all usually happen because the person is no longer self-conscious.

I find people over 65 particularly interesting to paint. Their poses are usually simple and straightforward which really acts as a frame for the wealth of character most have. I have a friend who is 72 and when I see her she's usually natural and quite unassuming. When I asked her to pose for a small sketch group I was part of, she was delighted. When I picked her up the evening of the sketch class, I was greeted at the door by a Mary I had never seen before. Her hair had been done that day, she was tastefully made up and dressed to the teeth! Though it was fun painting Mary that evening, I would have preferred her sweet and unassuming self.

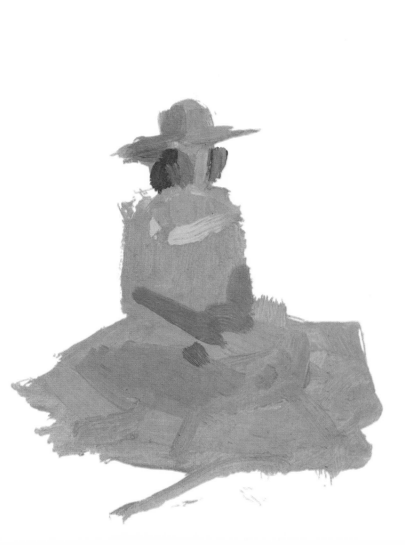

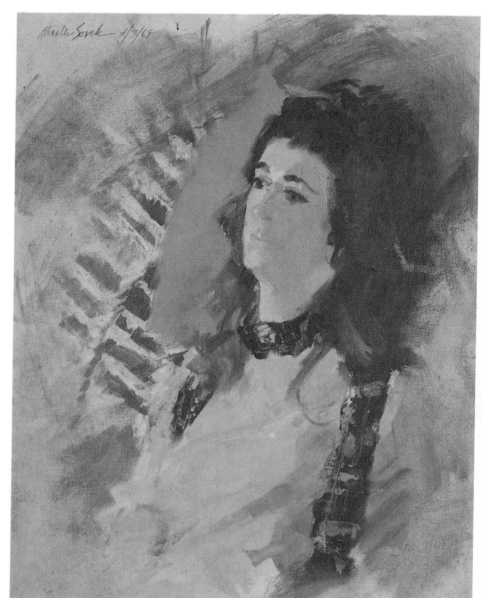

Kids can provide endless variations of shapes and color, sparked to life by everchanging gestures. They can be frustrating if doing a slow sustained study. By working quickly, however, even to the point of laying in a couple different poses and working on whichever one the child happens to be in, they can be rewarding. Household pets can also be willing models, they are good for longer studies when asleep and quick notations, drawings or color, when eating or playing.

As you gain in confidence, longer poses and larger pictures should be attempted. It's a good idea also to think about what you're doing with a composition rather than just a study. Even a single figure with no background or props can be a picture. It's a matter of composing or placement. The young woman in the chair reading on page 106 works as a picture because I was careful in positioning her on the canvas with her head placed far enough to the right to make a pleasing shape in front of her. This also prevents your eye from going out of the left side of the picture along with the gaze of the woman's eyes.

Doing a self-portrait is another excellent way to develop your painting ability as well as do some interesting composing. A large mirror placed in front of your easel can provide an instant model. For centuries artists have been painting themselves. Rembrandt, in particular, painted self-portraits in all manner of costume and hats. If you have the space in your studio, you can set up a second mirror which enables you to paint yourself from almost any position.

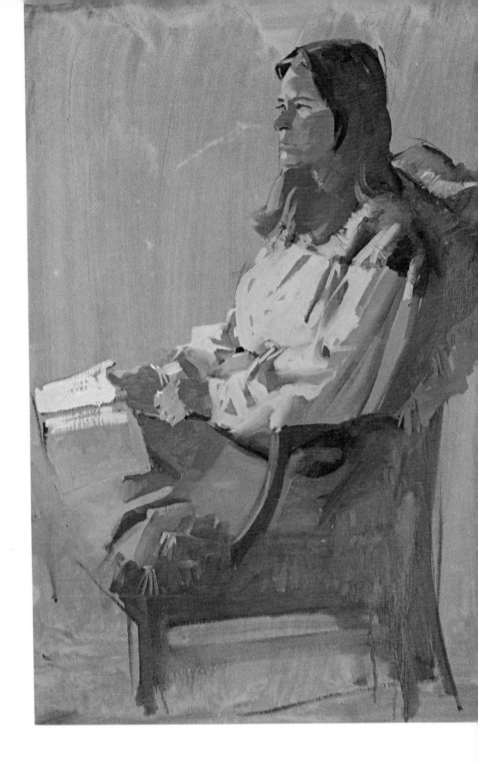

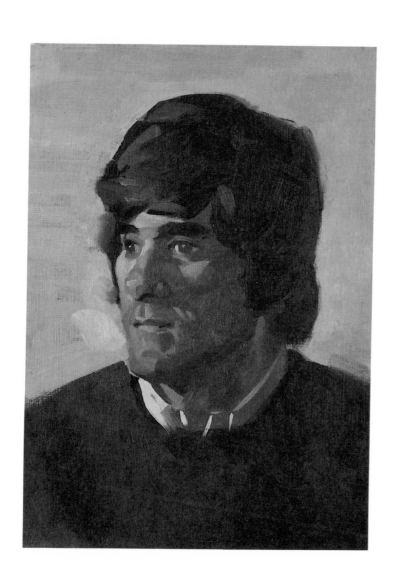

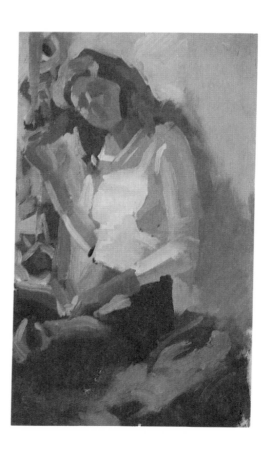

Painting white has always been fun for me. I'm fascinated by the way light shines on white making subtle variations of warm and cool grays with hints of reflected colors. This picture was handled simply but great care was taken not to overmix the color. The treatment of edges was also important in giving dimension to the room. By focusing on the area around the window and seated figure while softening most of the other areas, a center of interest is formed. I always try to focus on one or two particular places and subordinate everything else. This way, the viewer's eye will have some place to land rather than wander aimlessly over the whole painting.

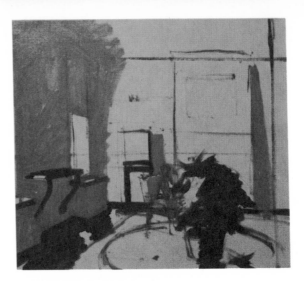

"THE WHITE ROOM"
Step One

After toning the canvas a light warm Ochre, I start by drawing directly with a brush. Placement and proportion are my main concern. I strive to draw as I paint and too detailed a drawing would inhibit me. A painting should look spontaneous.

"THE WHITE ROOM"
Step Two

Keeping my light source in mind (the windows), I'm now establishing my values, working simply—almost poster-like —I try to feel the large forms in the room. What kind of pattern do these forms suggest? Where will my lightest lights and darkest darks be placed? If the light is cool, shall I make the shadows warm? How warm? All these questions need answering and now the is the time to do it.

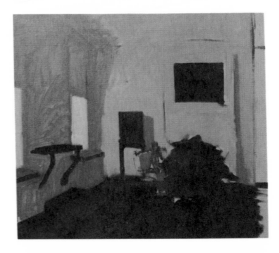

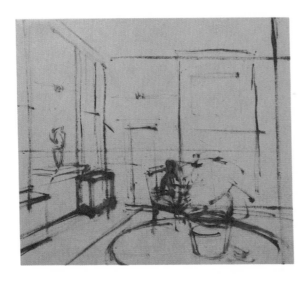

"THE WHITE ROOM"
Color Sketch

Before starting an involved painting, I find a small color sketch can help me visualize some of the problems. This sketch is about 4x4 inches and is done in oil.

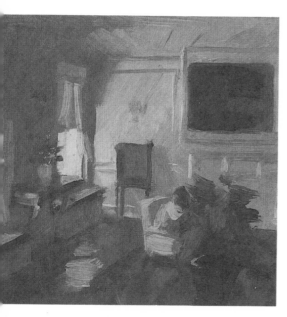

"THE WHITE ROOM"
Step Three

Now the parts of the picture are getting attention. What was a flat wall now starts to show the dissipating values of light shining on it. The entire canvas has been covered and I can call attention to detail. The figure will be placed soon. Notice I've painted completely over where the figure will be, rather than carefully painting around her. One advantage of oils is being able to work back into any covered area. If the paint gets too thick, take your painting knife and scrape some of the excess paint away.

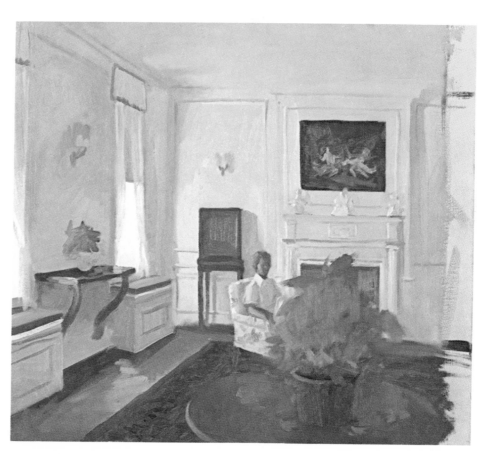

"THE WHITE ROOM"
16x18 Oil on Canvas
Finished Painting

Here's the finished painting. The figure has been placed giving scale to the room. The walls, decoration, windows and floor have all been indicated. By keeping detail to a minimum and handling the paint in a broad manner, the painting begins to capture some of the freshness that prompted me to paint this room. My total painting time was about six hours with an additional hour spent on the color sketch.

109

"WESTPORT WINTER"

Here is one of those cold days I talked about. My palette was Burnt Sienna, Ultramarine, Alizarin Crimson, Cadmium Orange, Burnt Umber, Cadmium Yellow Medium and White. I recall toning the panel with a wash of Burnt Sienna thinned with turpentine which helped the sunlight on the white house stand out nicely.

"EVELYN"
15x17½ Acrylic

This is my good friend, Evelyn Welch, on a summer evening looking at her garden. Movie makers call this time of day magic time because everything looks so warm and friendly with the low warm sunlight.

"SUNDAY NIGHT"

Another low sun picture painted from out my studio window. Less than an hour was spent on this picture, but I worked every minute at top speed, racing the sun before it went down. The car and van serve as a nice center of interest.

"THE PANTRY"
18x20 Oil on Panel

Who can resist a pantry? Not me. As a kid, I remember going in to my grandmother's where all the good things were kept. When I saw this pantry I probably thought about Granny's. Everybody is prompted to paint subjects for different reasons. That's why most artists' work looks completely individual. The windows at the far end of the pantry give a lot of depth to the picture. This is another painting that was cropped a little to improve the composition.

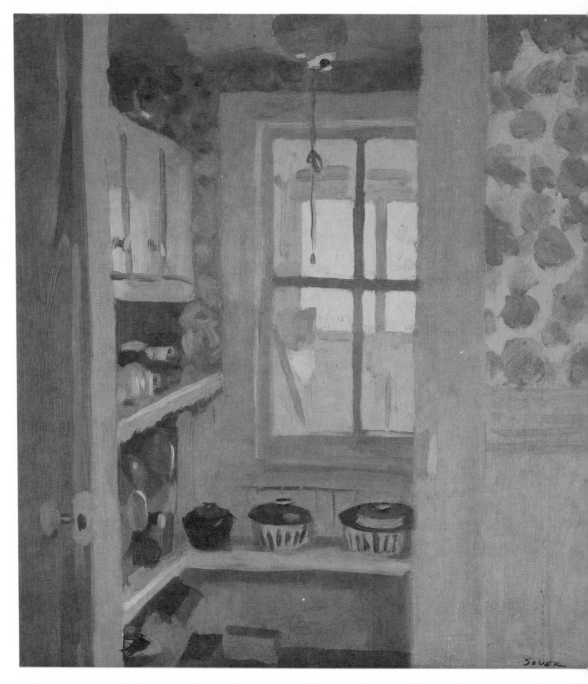

"Westport Winter" (page 111) and "Sunday Night" (page 112) were done indoors looking out as discussed in Chapter 5. Because of the rapidly changing lighting conditions, no more than two hours was spent on either one of them. Painting cold winter scenes from indoors was a real treat compared to being outdoors in the cold or in a car with the windows steaming up and the windshield wipers whipping back and forth.

Like drawing and values, the real use of color is to help capture the environment around you. Showing it the way you see it. Color can be a lifelong pursuit and the more pictures you paint, the more sensitive your eye becomes to its subtleties. By avoiding formulas and keeping an open enough mind to be surprised by commonplace objects under various lighting conditions, you'll develop and grow as a colorist. Like anything else, some people use color more easily than others. Whatever your level, however, good pictures can be painted by simply seeing scenes through your own eyes and choosing color not for any academic principle, but to express how you feel about what you see. Color can then be used as a way to express your own personal poetry.

CHAPTER 7
Putting People in Your Pictures

Having dealt with some color aspects of painting people, we'll now back up slightly and consider drawing, construction, gesture, and the placement of figures in an environment.

Just because you've never drawn a person before doesn't mean you can't do it. How many times I've heard "I don't do people, just landscape or still-life." Unfortunately, too many artists have this attitude and it doesn't have to be that way.

With a couple of guidelines and a little courage there's no reason why you can't develop a way of putting believable people into your pictures. It's not likely you'll develop into a second Michelangelo but that's not important. What is essential is feeling comfortable drawing people, and having the know-how to put figures into your paintings whenever you feel they're needed. Starting is as simple as asking someone to pose.

Before you start to draw, however, ask yourself this question. What is the figure doing? Sitting? Standing? Leaning? Slouching? What? By first recognizing the GESTURE of the person, you will have grasped an essential part of what drawing people is all about. To clearly show gesture you'll need to simplify the figure into basic forms. This not only helps us to understand more easily how the figure is constructed, it also keeps us from getting bogged down with small details. Shoe-laces, buckles, bows, wrinkles and eyelashes are all important, but should be thought of only after the larger forms of the feet, upper and lower torso, head, arms and legs are drawn.

By using a simplified version of how a person is built, you'll be able to visualize the figure more easily and keep those larger, more important forms under control.

There are many ways artists use to simplify the figure. My method has evolved by combining many of these procedures to fit my own needs in drawing.

Remember, there's no one right way—we all see a little differently, therefore our ways may be different. Use as much or as little from my method as you wish. Trust your own needs and build on them. If you can put people in your pictures in a believable way, whatever method you choose will be the right one for you.

Before drawing particular people—men, women, children or assorted characters—you have to learn to see the basic forms under the surface. If you draw the figure in a simplified way, the movable parts of the body, the head, upper and lower torso, arms and legs, are much easier to control. Indeed, every aspect of the figure is easier to understand and manage.

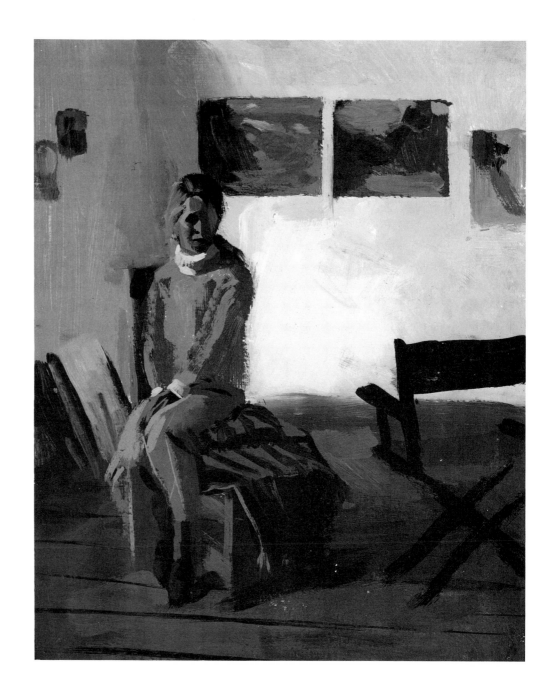

"MUFFIN"
12x15 Acrylic on Panel

One day Christy brought a friend to pose at our sketch class. Muffin never posed before and did well. The soft light from the north window defines the figure and the room nicely. How dull the composition would have been without the figure.

The drawings shown here are simplified versions of parts of the figure. Let's start with the head which is basically a rounded, egg-shaped form. Hair styles, glasses or squarish features may disguise that roundish quality, but under them is still the egg-shaped form of the skull. The neck can be thought of as a simple tube-like form rising out of the shoulders. No matter how many necklaces or fancy collars you choose to put around the neck, this tube-like form should be apparent.

The upper torso gets more complex. I like to visualize it as a rectangular pillow-shape. Some artists see it as a barrel, others a brick-like form. The difficulty in drawing the upper torso is visualizing where and how the arms attach. This is no easy job because the arms are so flexible and move in so many different ways.

This same problem exists with the lower torso, but to a lesser degree, because the legs aren't as flexible as the arms. By visualizing the lower torso as an egg with both ends sliced off, you can easily place it under the upper torso. In this way both sections of the torso can move to whatever position the action calls for.

Arms and legs can be thought of as simple tapered tubes. A little later we'll deal with the hands and feet.

Whatever methods you choose to visualize the head, upper and lower torso and other sections of the body, think of them as solid and three dimensional. Keep the figure's bulk in mind by asking yourself questions like: How much would your figure weigh if he stepped on a scale? Could you put your arms around him and give him a hug?

Start looking at people in terms of these big simple forms. Learn to draw the simplified figure forms in all kinds of positions without a model. It'll help you understand action, proportion, foreshortening and form. Such exercises can serve as an excellent basis for learning to draw the figure.

116

Being able to visualize and draw static basic forms, however, is not enough if you want alive, believable-looking people. We have to add to this, gesture, or what the figure is doing. In a certain sense you can say everything has gesture, a door ajar, a chair pushed away from a table, a plant directing its growth toward the nearest window. Basically, gesture is evidence of life. When you begin to understand what the gesture of something is, your drawings will start to look convincing.

The drawings here are concerned with gesture. By combining gesture with the basic forms, I'm not only constructing a figure but having it do something as well. Reaching, bending, lying, sitting, kneeling, all the things we do every day. I usually start with the head, add the upper and lower torso, then build on the tube-like forms of the arms and legs. Keep your procedure flexible though, by sometimes starting with the lower torso, as in a sitting figure, where the lower torso is supporting the weight. Try to draw each figure individually rather than always starting with the head, then upper and lower torso, arms and legs. There may even be times when you'll start with the hands or feet if they are an important part of the gesture. Avoid drawing tightly and mechanically. Draw with your arm and try to get some swing into the strokes as you draw. What you don't want to do is pick away using only the motion of your fingers. Keep far enough away from your drawing as you work so you can take in the figure, rather than getting your head so close all you can see is the head or a hand or some other part. See and draw the whole figure.

Draw from real people, photographs, the television set, pets, whatever is around you and convenient to draw. Work whatever size is comfortable to you and do lots of drawings. Forget folds and wrinkles and go for the big forms and gestures. Later you can add drapery and other details. Get the feeling of gesture into your drawings first and you'll see how the rest will fall naturally into place.

It is important to develop a procedure that's right for you. By taking one step at a time we can more easily concentrate on a particular problem, solve it, and move on to the next.

The following demonstration shows my procedure in drawing a figure. I don't draw exactly this way every time—sometimes I work simpler, more linear, other times tones are stressed. Whichever way I'm drawing at any given time, however, I'm thinking of the steps shown here.

Even before picking up a pencil I like to just look at the pose for a couple of minutes and try to get an initial impression of what I like or don't like about what the figure is doing. What interests me? The answer could be anything from an interesting arrangement of light and dark patterns, a unique gesture, a quality of character which strikes a response, or perhaps the intriguing shapes the light and shadow make on the figure. Knowing what interests you will help you emphasize that quality in your drawing. It will also help you avoid getting stuck copying everything you see on the model and hoping that by doing this throughout the figure, some magic will take place and a beautiful drawing will result. Unfortunately this is not the case. What you see is what you get. A beautiful drawing must deliver more than just a catalog of facts.

Step one then is a long look deciding what you want to stress in the pose of the figure in front of you.

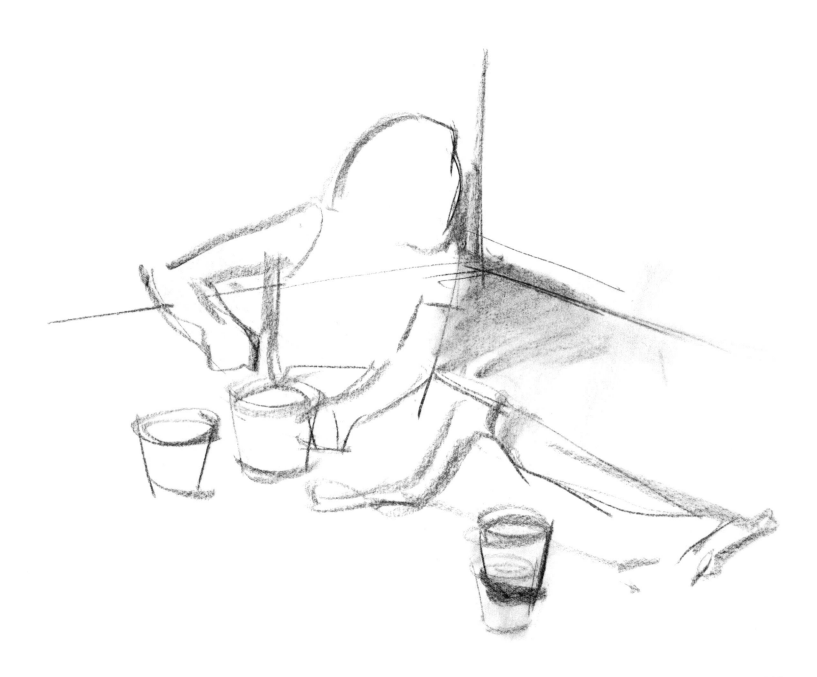

Step two should be done as quickly as possible. You are now concerned with the gesture. This step is not so much a matter of accuracy of any one part as much as it is the gesture of the *whole*. I try to let my hand skate over the surface of the paper feeling the whole pose as I draw. Sometimes a few lines will catch the gesture, other times many lines will be needed and occasionally a fresh start will have to be made.

Because you're working simply, adjustments or a new start aren't nearly as difficult as it would be in a tight, detailed drawing. Start simply, work quickly, and don't be afraid to start over if you feel you haven't caught the gesture.

In this next intermediate stage of the drawing you are concerned with the development of the parts of the figure. Concentrate on the big forms, and suggest the hair, important features, a few of the prominent folds in the clothing. As the drawing grows, more details can be added. Because you are drawing on top of your original gesture drawing, you'll be able to keep an eye on the whole as you develop individual areas.

About this point you should consider putting in a simple light and shadow pattern. Once the structure has been drawn you can place the shadow pattern with confidence, even changing it where needed. This would be impossible if you aimlessly copied the shadows with no idea of the forms under them.

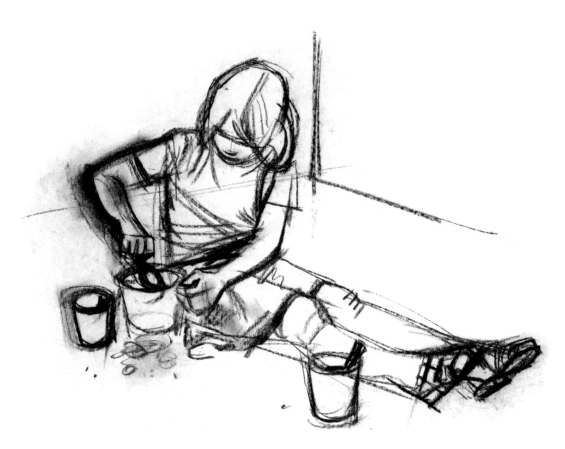

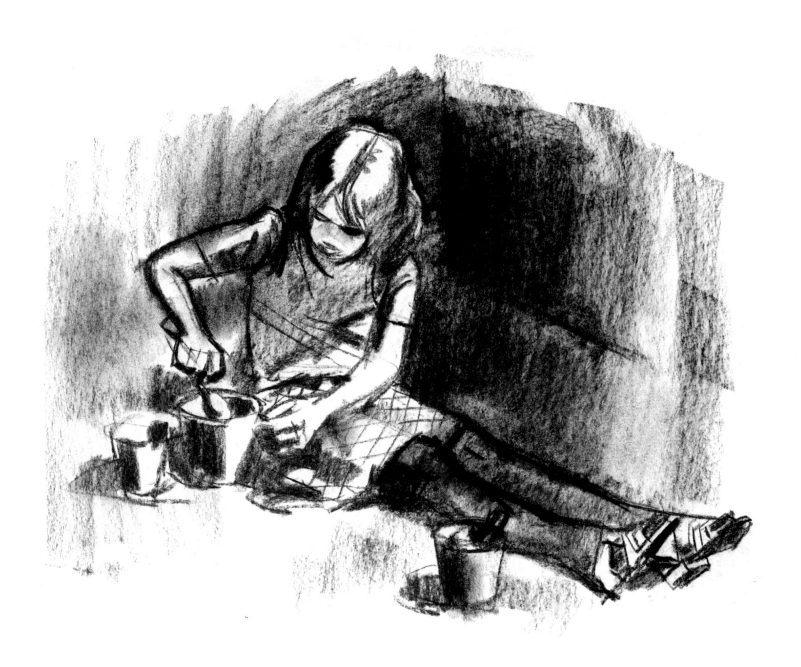

Now it's time for the final rendering. Care should be taken to build the smallest details into the drawing. Like a completed jig-saw puzzle, everything must fit. The nose should come out of the face rather than sit on top of it. The eye fits into the socket, and the socket into the head. Eyelashes grow out of the eyelid and are not lines drawn on top of it.

Whenever I get into trouble drawing very small details and fitting them into the drawing. I'll draw an enlarged version on a separate piece of paper and work out the problems there. By seeing the forms larger, it helps to clarify how they are built. Perhaps, you'll find this procedure helpful.

Finishing a drawing can be as difficult as starting one. Not because we're unable to add all the detail we see, but because once the drawing takes shape and starts to look pretty good, the temptation is to overwork it. How do you know when to stop? There's no easy answer to that question. Everyone has to find his or her degree of finish. One question you might ask yourself is, have I, at this point, accomplished what I originally set out to do?

No doubt you've experienced hearing a speaker deliver a message crisply and briefly in five minutes but then, go on another five minutes repeating himself. As a result, he ends up saying less and being less effective than if he had stopped after the first five minutes. Keep this in mind when you draw and paint. Knowing when to stop a drawing requires the same kind of discipline. Once you've said what you've set out to do, stop, take one final look for anything important you might have missed and put down your drawing tools.

Someone once said it takes two people to make a picture, one to paint it and another one to tell the first one when to stop. There is much truth to it.

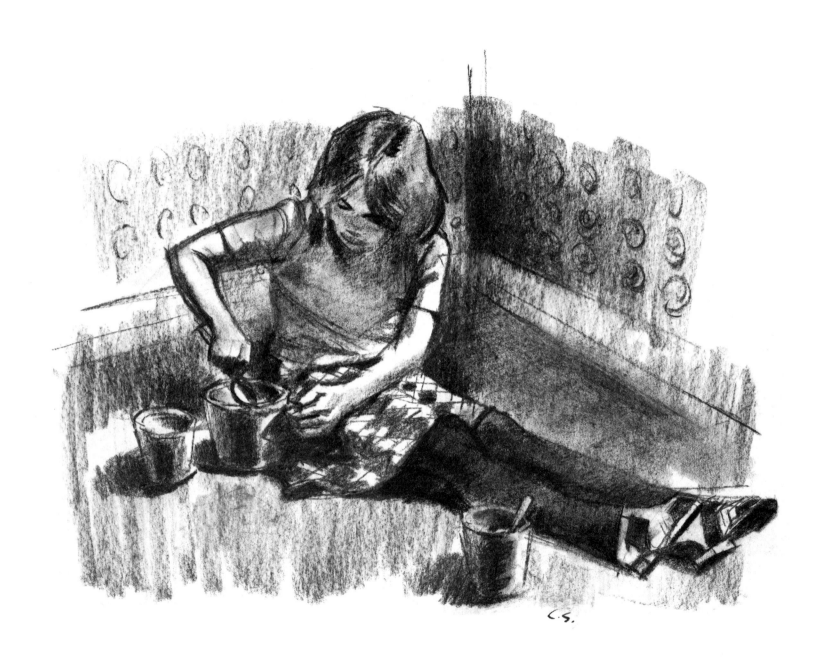

you can contrive props that seem appropriate to the person posing. The big sombrero and the feathery neck piece seemed right when I was posing my friend Lisa shown here. Props have always intrigued me and I'm constantly collecting new ones. In fact if my good neighbors didn't know I was an artist, they might logically conclude I was a junk collector.

At some point you should try larger compositions. Include people, props and the room they're in. Major paintings like this usually take quite a bit of planning and preliminary work. Composing a figure in a room depends almost entirely on the artist's personal view of how he sees the scene. The viewfinder mentioned in Chapter One is useful in helping you see, compose, and try different viewpoints. I've been intrigued for a long time with motion pictures and especially the actual composing of the scenes through the camera. An artist can learn a lot watching how the motion picture camera sometimes looks down on a scene, other times up, some scenes encompass a vast landscape, others focus in tightly on a person.

Pacing and variety are major artistic considerations in every art form. When you look through your viewfinder searching for points of view, be selective. And think how you might do the scene if you were working with a movie camera.

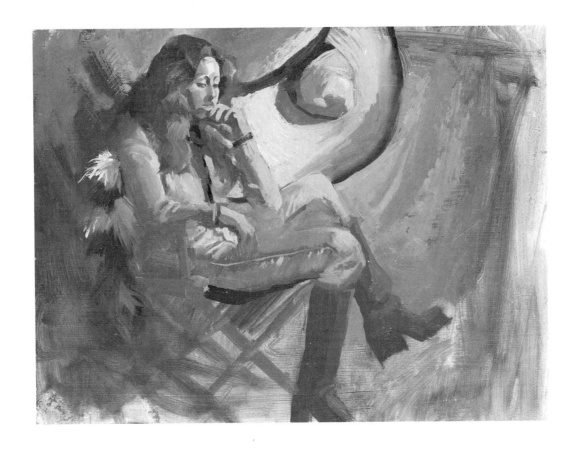

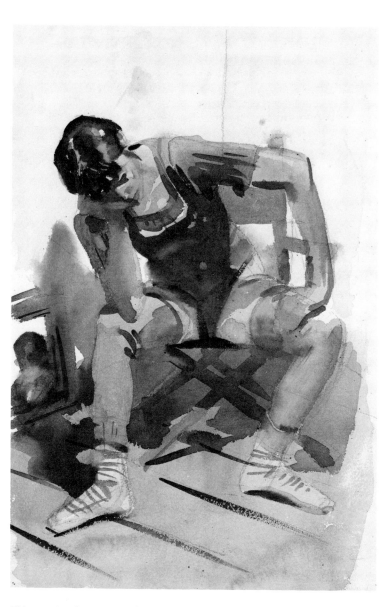

This pensive dancer is really an artist in her own right who also dances. The pattern of the costume, the shoes and the simple indication of boards on the floor make a clean composition. The slightly downward point of view shows the shape the figure makes in an interesting way.

One cold winter evening my friend Bruce and I were the only ones to show up for a sketch class. Dressed in his hat and a couple of layers of sweaters and sporting a new beard, Bruce looked just right for a picture and I asked him to pose. He asked if he could read while posing and this added his glasses to the props. Though this is just a head drawing with a little of the shoulders showing, the props imply much more. The grey pastel paper helps tie everything together. Had this been done on white paper without a unifying neutral background the picture probably would have looked too busy.

The way I usually approach painting a figure into an environment is to ask the person to take a nice relaxed pose. Then, with my viewfinder, I really scan the area. For example, a child sitting on the floor playing with some toys can look quite different seen from different points of view in a room. Looking down on the child will take the viewpoint that adults usually see children. Whereas a head on view showing the child absorbed in play can have a straightforward quality to it. Many portraits of children are also done from this point of view. Then, of course, there's the point of view of looking up at the child. Paintings done from this view can have a unique and interesting quality.

Now let's look at the same scene from different distances. The closest you want to get to a person is to show the head about life size. At larger than life size, the head is likely to take on a grotesque quality. Painting a child's head life size will work well, enabling us to concentrate on the expression, delicate modeling of the planes and quality of color. I find, however, this close point of view is usually more successful in photographs. For some reason, just a large head on a canvas with little else is apt to look sparse and incomplete.

Moving back a few feet, allows you to include the neck, shoulders and perhaps one or both hands and a little background. This is the classic portrait viewpoint. The head is still the center of interest but there is more variety. Hands, which can and should be used expressively, and some background in which to place the figure, will complete the composition. Many fine paintings have been done from this viewpoint including some of Robert Henri's sensitive portraits of children. Contemporary portrait painters, Aaron Shikler and John Norton often choose this point of view.

Moving back still farther, we now can see the whole figure—a chair if the figure is seated, and even more background. Mary Cassatt is unrivaled for painting children's full figures and placing them in a simple environment. Cassatt also created interesting compositions. Influenced by her friend Degas, she, too, explored many previously untried, fresh points of view. Her painting, "Le Toilette" showing a mother with her child looks as fresh and alive as when she painted it nearly a hundred years ago. This talented artist's works deserve close inspection for anyone interested in the honest portrayal of children and motherhood.

Sargent also enjoyed painting full length portraits of children and, with his unerring eye, was able to not only paint one child, but groups as well. His famous painting of the Boit children places four little girls into a large Victorian room, capturing each child's uniqueness without making any one of them a central figure. Though Sargent was a great artist whom I've always admired, I feel he never quite caught the spirit of the children he painted. The form and rich surface quality is there, but when compared to Mary Cassatt's or Robert Henri's paintings of children, Sargent's children look rather lifeless.

Moving our easel back farther, we see a lot more of the room. The figure now is about equal in importance with the room. I've always felt one or the other should dominate and unless you're doing a group of people from this viewpoint, it's usually not that interesting.

Going back still more, the room now occupies more space on the canvas than the figure. This is another classical point of view. Velasquez painted many of his famous portraits of Spanish nobility from this point of view as did Sargent in his paintings of Venetian interiors. There are innumerable compositions available to study from this angle.

Taking another clue from the movies, we can look through and around things. Even commonplace objects can look interesting when used this way. My painting of the large white room with a figure on page 109 uses this idea showing a table with a vase of flowers in the foreground and the figure, smaller, seated in a chair in back of it.

Going back to our composition with the child, a rocking chair in the foreground with a child playing on a rug at midpoint with the rest of the room in the background could give a warm, intimate quality to the scene. Compare this idea with the painting on page 81 where the wall is in the foreground, the child sleeping on a rocker at midpoint with a window and wall in the background.

Finally, there is the view looking from one room into another. Though it contains no figure, the painting on page 65 takes this approach. Andrew Wyeth occasionally uses this room-to-room kind of composition both with and without figures.

With all these various views available to the artist, it can be a problem deciding which one works best. The more paintings you do, the more your compositional eye will improve and you'll be able to anticipate what point of view is just right for what subject.

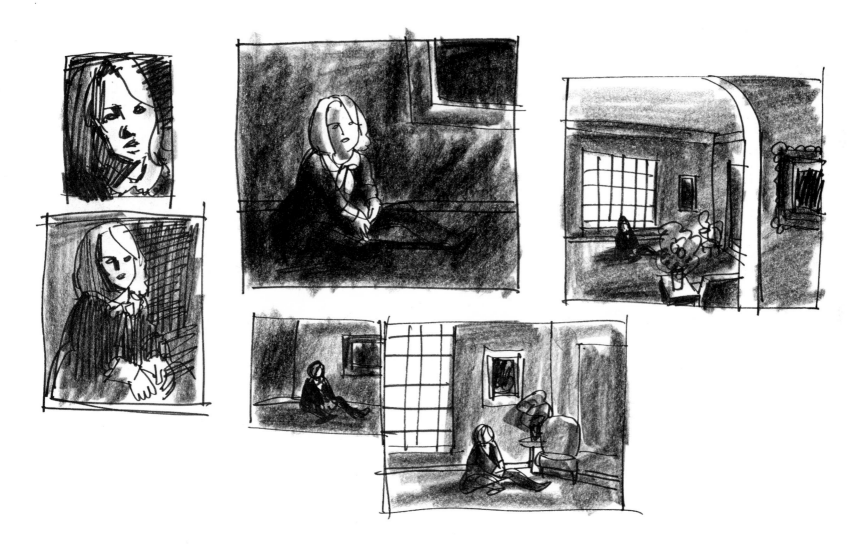

Don't be easily satisfied. With quick, small sketches a lot of variations can be tried and compared. The right one will usually stand out. To show the many pictorial possibilities available and how each one conveys a different mood, I've taken the subject of the child and made compositional sketches from many different views. Even in sketch form, notice how each one shows the child a little differently. Take a subject of your own and try these same exercises. See how many different compositional possibilities you can develop from the same subject.

Another aspect of putting people in your pictures is showing them at work and play. Degas' series of laundrymaids and Van Gogh's "The Weavers" are accurate, sympathetic pictures of people working. Winslow Homer used people at work in a number of his paintings. His storekeepers, reapers and schoolteachers are not only fine paintings but an accurate record of the way things were done a century ago. Homer also depicted the leisure life. His croquette players and sturdy New England boys shown in his painting, "Snapping the Whip" are delightful pictures of people at play. Cezanne captured the spirit of the moment in his famous painting "The Card Players" and Chardin's "House of Cards" shows a single boy totally involved in playful activity.

There's always something fascinating about watching other people involved in what they do well. Norman Rockwell used this idea in "The Watch Repairman" where we see a kindly, yet knowing old watchmaker with all his magnifying glasses attached to his normal glasses inspecting a watch brought in by an innocent young boy.

Everyone has access to people working around them—garages, factories, offices. Edward Hopper used offices as scenes for paintings. He also painted a woman at work as an usher in back of a lonely movie theater. Someone involved in a hobby, a cluttered basement, an empty garage, the hallway in a school, a doctor's office, each one of these scenes evoke feelings about places we've experienced. What were the people doing in them? How was the place lit? Try to recall the touch of things—was the carpet soft to walk on? Did the armrest on a chair feel smooth? Was there a new smell to the room? Was there the smell of machines? Or perhaps an old smell? Thinking back about being in places that might make interesting paintings can be rewarding. Think with a pencil in your hand and make small sketches of your ideas as they come to you. If you have a picture in mind of people doing something in a place that no longer is, find a room that looks like it, have a few friends pose approximating what the people were doing and make some studies. In your studio, combine these with what your memories were of the scene and try to reconstruct that scene in your painting. Accuracy isn't nearly as important as showing how the scene looked and felt to you. Approach your work like a poet rather than an architect.

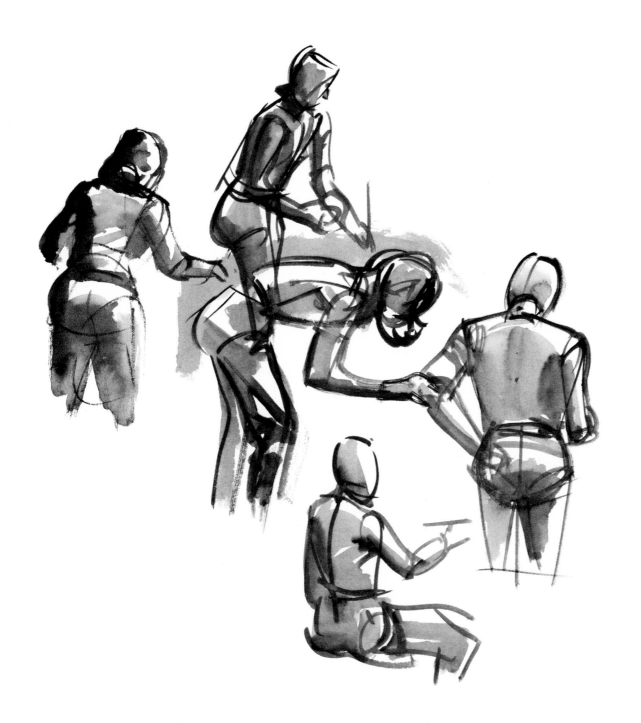

CHAPTER 8
Reference Material

Reference material is just what the word implies. Information gathered can be in the form of sketches, paint studies, photographs or images remembered and jotted down later. Few people include their memories as a source of information for their pictures. When remembering a place, I retain the images that impressed me and tend to disgard everything else. Of all the ways you use to collect reference material, memory painting will probably yield the most intimate results. Using photographs as reference is likely to result in just the opposite. Unless you're careful, little individual quality will be evident. Because photographs are so easy to take, the camera usually ends up doing the looking and not the artist. Fortunately we can combine our use of reference material to fit our needs.

When is reference material important? When time is limited, working conditions impossible, poor lighting conditions, or fast changing activity going on that makes prolonged, direct observation of the scene unfeasible. I've sketched in a theater backstage during rehearsals. The subject matter was inspiring, the people and props exciting and the color and mood a perfect backdrop for some possible paintings. The only material I was able to come away with, however, were drawings in my sketchbook. When I do the paintings of this subject I'll be needing more information than my sketches will give me. I'll need to know about particular colors and values, exactly what the props look like, and detailed

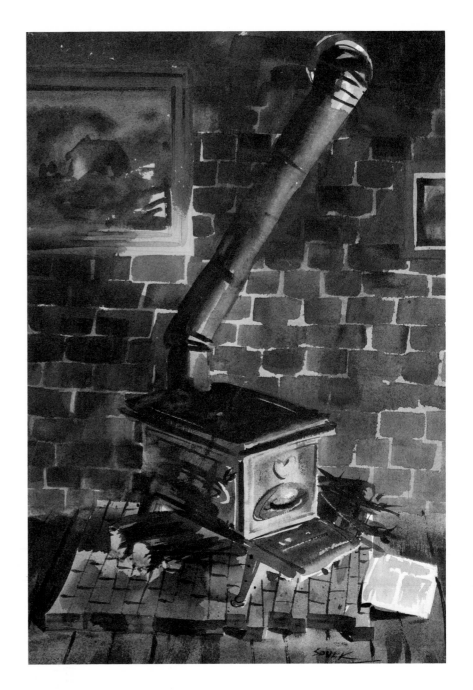

"WOODBURNER"
14x20 Watercolor on Paper

This watercolor was painted from a drawing. The drawing was done from a photograph. The photo was so poor I could hardly make out the objects. Because I saw the old stove, smelled it, and touched it, the photo didn't hold me back. I added what I knew to be there. Working from photographs can be rewarding so long as you stay in control.

information of the costumes as well as the character of the actors wearing them. Most of this information falls under the category of detail gathering and when I return to the theater, I'll be doing just that. Photos will be taken of anything that looks usable in my painting and detailed drawings will be made of those props and costumes that I want to explore more thoroughly. Written pencil notations will be made, possibly supplemented with one or two painting studies.

Though these bits and pieces of detailed information are important to making a painting, it's my original sketchbook impressions that inspired me and originally planted the idea for a picture in my mind. When I made the drawings in my sketchbook the moods were there, the theater was alive with people and what they were doing, and though my sketches were fast and sometimes crude, they picked up the spirit of what was going on. The mood of the theater when I return to take photographs and draw details of props and costumes may be much different than the time I made my sketches. The factual information will be there but I doubt if the mood will be, or the magic that inspired me to make my original drawings. Knowing this, when I return to my studio to paint, my chief source of reference will be the sketchbook drawings and what they evoke, sounds and smells along with the visual recalling of how it was. Subordinated to this will be the reference photos, drawings and paint sketches. By approaching pictures this way, the odds are much better for capturing that illusive quality of 'aliveness' that I want my painting to have.

The kinds of sketches and drawings I make for reference vary with the situation and how much time I have. Most of the drawings shown here were unconsciously simplified as I drew. Looking back over the years of drawing, this effort to simplify has been important to me. Catching the big quality of a gesture, seeing large forms, simplifying shapes, this is the way I've learned to see things. At some point I may choose to work precisely. If so, my seeing won't change, only my way of putting the image on canvas or paper.

These drawings are typical of the kind of shorthand I've developed to record a fast-moving scene or event. Sometime the emphasis is on shape and the contour of things, other times the masses, and still other times values and lighting.

The paint sketch gave me a lot of information about the values and color of the scene. Working small, 5x7 or 8x10, they can be done quickly and are helpful in recalling values, light and shadow patterns and color.

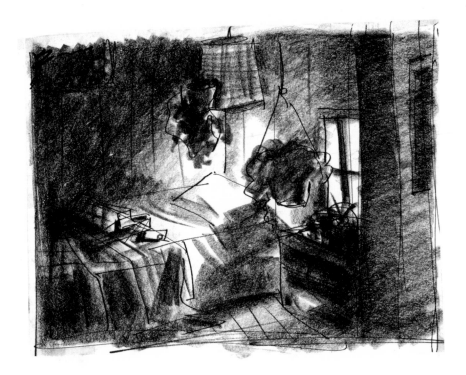

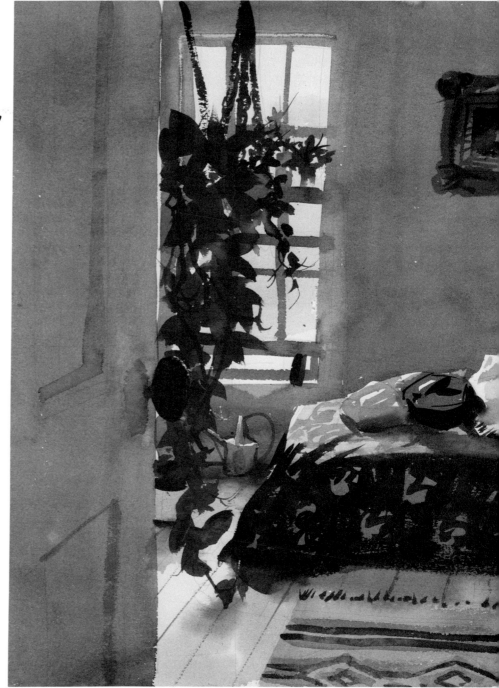

Another way to retain images for future pictures is memory painting. An instructor once told me about a Rudyard Kipling character who developed his visual memory to such a point as to be able to infiltrate an enemy encampment and by carefully looking at what he saw, retain enough information to make a detailed plan weeks later of the layout of the encampment. I found the story fascinating and I often try to accomplish equivalent mental gymnastics. While riding a subway or waiting for an appointment I look around and classify what I see for future reference. I've found this practice stimulating and occasionally the basis for a good picture. Where Kipling's character was interested in only factual information, the artists will be concerned with color, tones, interesting shapes and the patterns they make. I've found by looking at the whole scene rather than any particular detail, an impression remains and when back in the studio, that impression, when put into paint, will usually have the essence of the scene uncluttered by a lot of trivial material. Memory painting is nothing new. Whistler would have a friend describe the scene to him as he looked at it, then work from memory letting the words help trip the visual images he retained while looking at the scene.

"ART CLASS"
12x16 Oil on Panel

The Paier School of Art where I teach has painting studios lit by a top skylight. When the model poses under them, the effect is truly beautiful. I've observed this scene hundreds of times and one day decided to paint it from memory. Thinking of the studio itself as a large box, I visualized light coming in from the top and painted the students working at their easels, with the model invariably holding a pole on the stand. The figures were handled as gestures and shapes rather than features and folds. Memory painting can be a real test to see how well you observe and remember a scene.

We've all been confronted with scenes that could be potentially good paintings. A lonely hotel lobby at night, an intimate, warm neighborhood tavern in the wee hours, a nursery school on a sunny morning with all the shapes of toys, kids and pieces of small furniture scattered around. Handy as a camera is, it won't pick up that touch of poetry that we all see. Photos can help in remembering details and carefully drawn studies can give form to our ideas, but unless we're drawing from an idea, something we saw and felt, our painting is likely to end up a bunch of unrelated parts. Memory painting is an excellent way of capturing that first, important impression.

Painting from your sketches, written notations and drawings is another way pictures can be reconstructed in the studio, I find, however, this works better with landscapes than with interiors. A lot more artistic license can be taken outdoors with bushes, hills and rocks than indoors with the shape of a rocking chair or a fancy Tiffany lamp. You may have better luck than I working this way so give it a try.

When making sketches to be painted from later, fill the drawing with all the information you think you'll need. Written notations are particularly useful. Like Whistler, words can trigger many visual descriptions to support a few sketchy lines. Some of my descriptions read like rough drafts for a novel, usually something like...white plaster walls the color of eggshells and the texture of old cement sidewalks.... Reading these descriptions later in my studio, the images usually come popping back into my mind.

I find notations on color can be useful with words describing the color, value, intensity, warm or coolness or whatever other qualities are present. It is also helpful to know where the light is coming from, which edges appear harder and which softer, etc. All these questions should be asked as you draw and make notes. Forget if your paper looks overworked and covered with cryptic word descriptions. Soak up all that's important about the scene in front of you.

When painting from these sketches and supporting notes, tack them up in front of you and approach them as if the scene were in front of you. Another tip I find useful is to put the sketches and notes away after the painting is developed somewhat and trust your memory. Reviewing the sketches and notes will bring back a lot of information, but by relying on the sketches too heavily, the temptation is to copy and thus lose that first important impression that originally attracted you. Later the reference can be referred to again as needed, or discarded if your recall is complete enough. Paintings done from sketches seem to work better for me when done on small canvases, no larger than 16 x 20. Larger paintings require more consideration for detail and when not shown the result may appear skimpy and incomplete.

"UNDER THE CLOCK"

On the opposite page is a quick sketch made in a hotel dining area. The painting on this page was done from the sketch. I happen to like the drawing better, but it was fun painting from the sketch to see how much information I really captured.

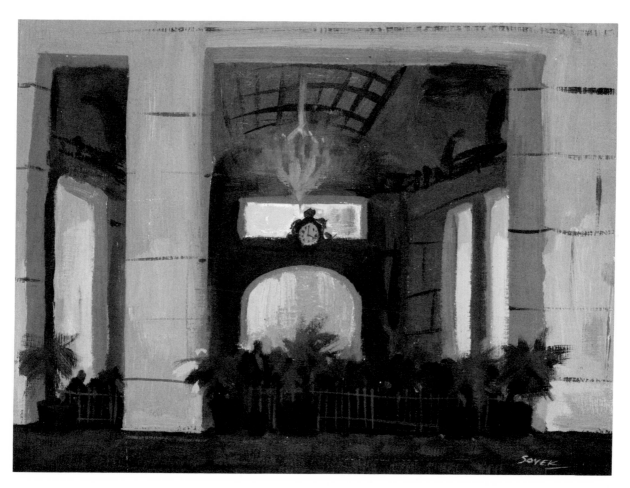

Another and seldom used kind of reference material is the scale model. Edward Hopper, when confronted with a problem visualizing light and shadow on a building, constructed a basic model of the building with cardboard and masking tape. Degas and Thomas Hart Benton would build clay models to help them visualize a difficult pose. Clay models work best with figures and animals and can be a lot of fun if you've never tried it. Some artists who specialize in painting ships find the plastic model kits a great help, particularly if they are concerned with ancient or unusual vessels. Cardboard models would be the most useful for indoor needs. An example of how to use such a model would be to reconstruct a memory of a patch of sunlight shining through a window and creating an interesting pattern across a coffee table and the floor. Your sketch shows the proportions of the window and table and you have an indication of the values and color, but the shape made by the sunlight escapes you. By folding some white cardboard into two walls and a floor, much like a shoebox with two sides missing, cut a small rectangular shaped hole approximating the window on the side of the box. Make a small box in the approximate shape of the coffee table, set in place, turn off any overhead lights, shine a flashlight through the window hole and presto—you have the lost shape the sunlight would have made!

The camera can be an enormously useful tool in painting pictures. That in itself sometimes generates a problem. The camera is so effective at capturing information that some artists are intimidated and feel obliged to copy what they see in the photographs and by doing so lose most of their own impulses. The results are likely to be rather ordinary paintings.

This does not have to be the case. Degas used photographs, and Winslow Homer in writing to a friend said, "I'm off to the Adirondacks and not without my trusty Kodak." Norman Rockwell found photographs an enormous aid in recording expression and character which is so obvious in the people he painted. These excellent artists used the camera as another helpful tool. In this way, photographs can contribute a great deal to your pictures. Before discussing the particulars of using photographs, let's talk about the camera itself.

I own five cameras, all of them were expensive and all have proved their usefulness. For a time I enjoyed photography so much I built a darkroom and processed my own prints. One day it occurred to me that photography was really an art form all its own and some of the photos I took stood as statements complete in themselves. Painting from them would be like copying another painting. This bothered me. I didn't want to turn photographer so I began to put less emphasis on the cameras and quality of photographs, and more on information that would help me do good paintings. I now use one medium priced 35mm camera for just about everything and, except for very difficult lighting situations, could easily get along with an Instamatic. Whatever kind of camera you now own is probably O.K. providing it takes reasonably clear pictures. If I had to recommend one camera to own, it would be the popular 35mm model. It's small enough to carry around easily and there are a dozen different kinds of film available. Some of the speeds are now fast enough to take pictures under the darkest of lighting conditions. No flash attachment is needed. A flash or strobe

light flattens out lighting and while it may be great for catching a puckered-up Uncle Al blowing out all the candles on his birthday cake, it's fatal to those quiet interior scenes with one light source softly defining a few objects and leaving the rest of the picture suggestive.

I usually work from prints but if you use slides you'll need a small viewing screen and projector.

Another pitfall is working from photos that are too good. Many of my photographer friends shake their heads in dismay for my lack of respect of good quality photographs. I don't like to compete with a photograph and by working from less than good ones, I find myself much less intimidated. I feel freer to change, adjust and improvise. The painting of my son Chip on page 57 was done from a poor photograph showing just enough information to spark my memory of how it was.

When you first start to work from photographs I recommend you use black and white pictures rather than color. You'll have one less problem to worry about and be able to concentrate your efforts on interpreting proportions, values and edges intelligently. Once this is mastered, then move onto color if you choose, but proceed cautiously. At the first sign of copying those colorless shadows, put the photo away and trust your memory. Jack Pellew has a sensible approach to painting from photographs. He puts the photo in front of him and makes a fairly complete drawing. The photo is then put away and the painting is made looking at the drawing. I might add that a postcard size color sketch done either from the photo or memory can complete the information needed to paint the picture. If there's one thing to avoid like the measles, it's sitting in front of a photograph, hour after hour with no thought except making an accurate copy. What the artist contributes is his own reaction to the scene. Without any personal involvement what's the point in painting?

How many times have you heard "The camera never lies," "A photograph sees exactly what's in front of it," or "It must be true, it's a photograph." None of those statements are true. The camera does lie and here's how. When you or I look at something, we're looking with both eyes. We're using our built-

Notice how the plants and the shelf they're on dip down out of the bottom of the picture. The window panes also look slightly distorted. This is because the photograph was taken very close to the objects. To correct this I've used perspective as shown in Chapter Two.

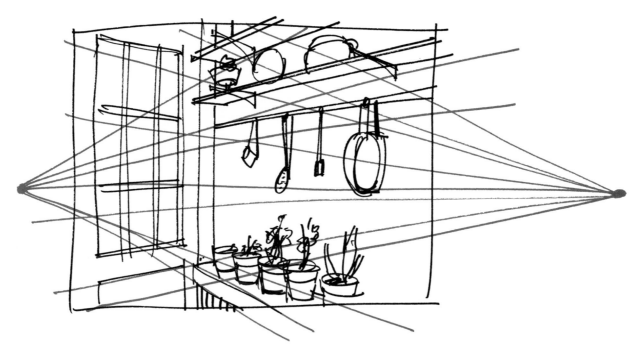

When I saw this photograph of the woman viewing paintings, I felt that showing more of the gallery would help the composition. In fact, the more gallery I show the better I like the composition. How would you interpret this picture?

in three dimensional glasses. There's volume in front of us. It's easy to see how far the chair or person is down the hall or the distance it would be to jump across that puddle. Close one eye and see what happens. Depth perception is greatly reduced; we can no longer judge distances and everything looks flat. Open our eyes and the world of dimension appears again.

A camera has only one eye. It cannot see depth. This one simple fact has confused a great many people who try to paint from photographs. When aware of this we start to look at photographs much more carefully and even suspiciously. We also start to use them for what they can do to help us. That is, the accumulation of detail, defining interesting value patterns, gestures and action too difficult to capture in a limited time.

I find it helpful in interpreting photos to reduce the objects I'm drawing in the photograph to their simplest forms. The area under a complicated dining room table for example would be a rectangular box-like shape. Seeing the objects in the photograph simply like this enables any error of distortion to be quickly corrected.

144

A final word about color in photographs. At some point you might paint a picture from a color photograph and hear a chorus of praise from nearly everyone who sees it. I don't want to take away any compliments from anybody, God knows, an artist can use all he can get. What I'm talking about is getting into a rut by working from color photos all the time. It's probable that there are a lot of people who would like *ANYTHING* done from a color photograph. After all, it's a view of life we're so used to seeing either from the family photos we all take, magazines, or that biggest of all source of pictures, the television set. A painting based on color photographs can easily be misinterpreted and viewed not as a painting, but as another version of color photography, judging it therefore by photographer's standards (the importance of the incident happening, pretty subject matter, etc.) and not by painter's standards (original color qualities, interesting pattern, shape and gestures, sensitive handling of the medium), which is the only way a painting can be objectively judged. I like to think that painting and even painting from photographs is a way to show who you are in an increasingly impersonal world. So when the flattery starts rolling in about how your painting looks just like a photograph, ask yourself if that's what you really want.

"EDWIANA"
14x18 Oil on Canvas

When Edwiana posed for me I had about 20 minutes available. Fortunately I had my camera and was able to take a photograph of her, the photo captured the charming quality that prompted me to want to paint her. A camera can be a very useful tool when there isn't time to make a drawing or paint a sketch.

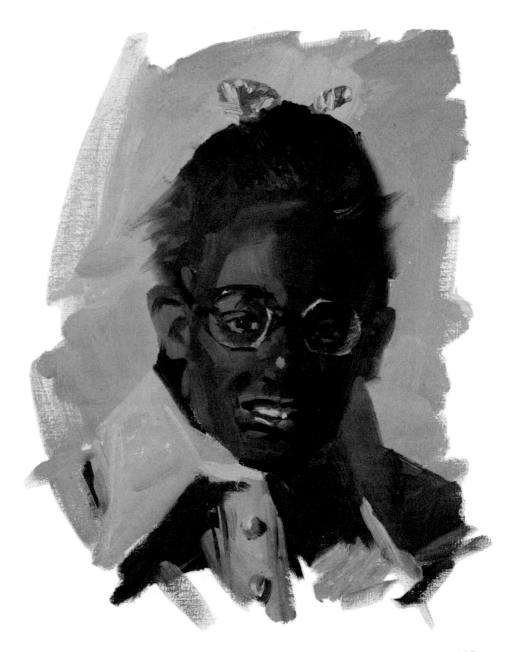

147

CHAPTER 9
Putting It All Together

Up to now, we've dealt with the individual steps in making a picture. Connecting these steps into a workable procedure is important if we hope to have proper control over what we're doing. In the following demonstration, I show a procedure to build a picture from the first germ of an idea through to the completed painting.

I like to think of each of the steps in my procedure as a building block for the step to follow. I try not to squander excitement on sketches and studies, but save myself for the finished painting. Some artists are hesitant to do sketches at all claiming they have more freshness and freedom than the finished painting. I usually feel more comfortable doing a couple of sketches, before plunging into the finished painting. If you feel hampered by preliminary sketches then you may be the type of artist who can best thrash out your picture problems directly on the finished canvas.

My painting ideas are usually triggered by observing something, a situation, an interesting effect of light and shadow, a person or a place suggesting a provocative mood. I have to be stimulated by something I see. The only way I can get involved into making a picture is when an outside stimulus gets my juices flowing. Not all artists work this way. Some can dream up ideas and carry them to finished paintings without leaving their studios. I think every artist varies in this respect and part of your development as a painter should be involved with discovering your way of triggering that mysterious mechanism that compels us to paint.

This demonstration is a scene at the Salmagundi Club in New York City. This delightful old art club has much character. A list of painters who have roamed the corridors and rooms of the Salmagundi Club over the past 100 years, would sound like a roster of Who's Who in realistic American painting. Shortly after becoming a member, I was asked to paint a portrait demonstration. I accepted feeling honored and then, thinking of all the great artists who painted demonstrations before me, I felt humble. I was determined to paint the best sketch I knew how. On the appointed evening I arrived early to setup. The club was just about empty except for the staff who worked there. It was February and the weather was cold and gray making a striking contrast with the warm, comfortable interior. As I walked into the main sitting room one of the younger employees was relaxing on a sofa reading the paper. The scene struck me as special because this room is usually filled with people chatting and looking at the paintings. That evening except for the one lone occupant the room was deserted.

I went on to paint my demonstration and enjoy the rest of the evening. A couple of months later when I was given some photos taken the evening of the demonstration, I remembered that intimate scene in the sitting room. I felt an urge to paint it. What follows shows how the painting developed.

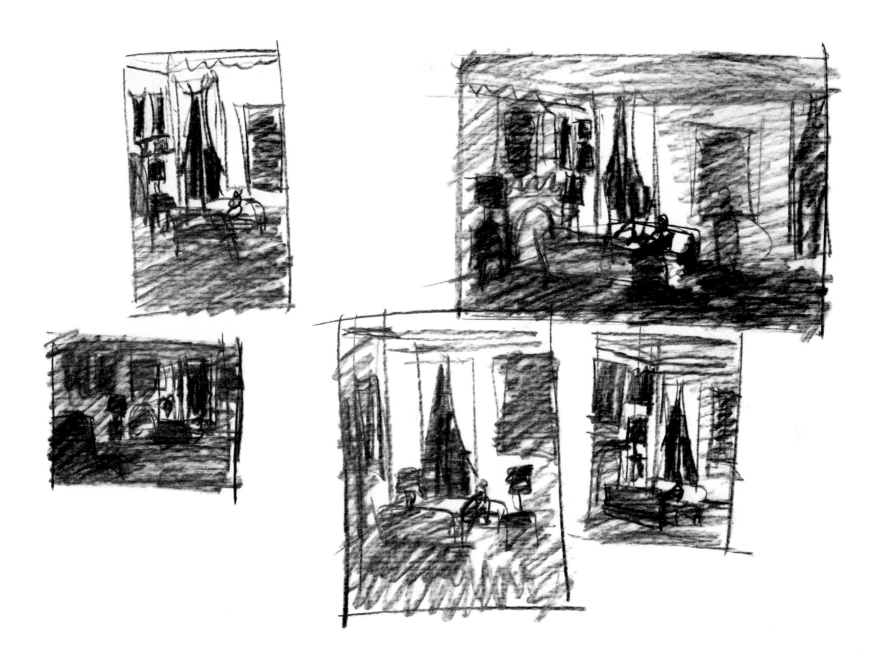

I started with a photograph of the sitting room plus some preliminary idea sketches and doodles of how I remembered the person reading the paper. My concern was to capture the idea. Drawing, values, and pattern were all worked out later. These sketches were only to get my original idea on paper in a way that approximates as closely as possible the mood I remember that cold February evening.

With the rough sketch of my idea completed I enlarged it to the size I wanted to paint, in this case 18 x 24 inches. This is important because a sketch can be effective when small, but lose a great deal when enlarged.

Working with soft charcoal on layout paper I drew freely, maintaining the general proportions of the small sketch but taking it further, adding more detail, indicating a light source. I thought about the perspective. I added a simple value pattern. In the small sketch I've shown only one of the lamps lit. In my enlarged drawing I based my light source on that one lamp. Notice in the photograph how the center of interest is on the fireplace and mantle rather than the sofa. This is because both lamps are lit defining that area clearly. I wanted to focus attention on the seated figure so I had only one lamp lit to emphasize the center of interest.

The general composition seemed to work, so it was time to solve some of the value and pattern problems. In the small paint study of the composition, little thought was given to detail. A lot of thought went into the pattern and values. Though small in size, this little paint sketch solved a lot of problems for me, showing in a simplified way how the finished painting would look. Paint sketches like this are easily made, and three or four can be done in a morning. On pages 62-63 I've used this composition as a basis to show some of the various lighting situations possible. Study these to see some other ways this room could have been painted.

Because the figure was an important part of the composition I had a friend take a photograph of me in the same position I remembered the man sitting on the sofa. The paint sketch shown here was done from that photo. Using the single lamp as my light source, I was able to place my light and shadow tones to give the illusion of light coming from that lamp.

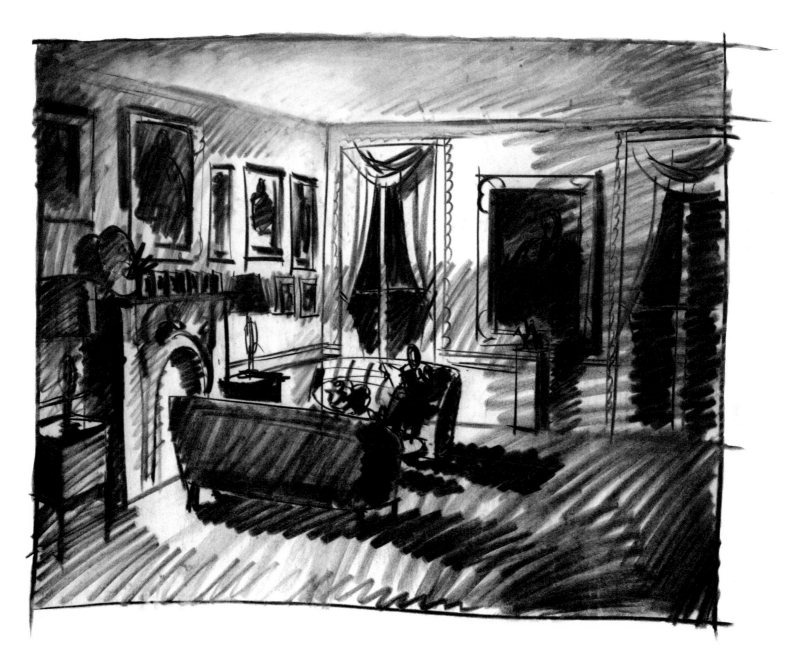

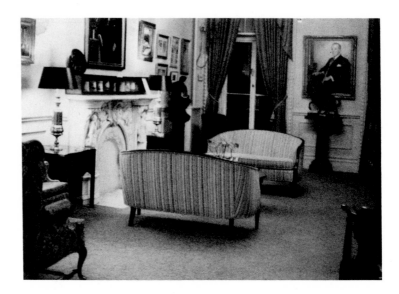

Once the idea for a picture gets rolling I like to move along as quickly as possible. A color sketch will be done only if I am uncertain of what I want to do with color. Because color and values are of prime interest in my paintings, I prefer to make a few nearly abstract swatches of color and value to give me a general direction, then jump to the finished painting.

Then I was ready to transfer my drawing to the canvas and start the finished painting. There are a couple of different ways of transferring drawings to the canvas or paper. In this case I blackened the back of my drawing with a soft graphite pencil, then taped the drawing onto the canvas and drew over the lines with a hard pencil. This transferred my drawing clearly enough to the canvas. I then went over the lines with ink to help me see them better once paint started to cover them.

Another way is to draw a grid of squares on top of your drawing, then draw the same grid in proportion on your canvas. Taking one square at a time, redraw whatever is in each appropriate square. A looser approach is to simply, refer to your finished drawing and, trusting your eye, draw directly onto the canvas.

The drawing shown is the finished brush and ink drawing done on canvas. I sharpened up the perspective and have gone into more detail with the furniture and objects in the room. Though not all the detail has been indicated, enough is there to give me a guide to the character of the room. Notice also how the line is thick enough to allow me to see it even after I've laid in my first tones with paint. By drawing with a brush instead of a pen, I was able to get a heavier line. The ink was black and waterproof which allowed me to wipe out paint in an area without disturbing the drawing beneath.

152

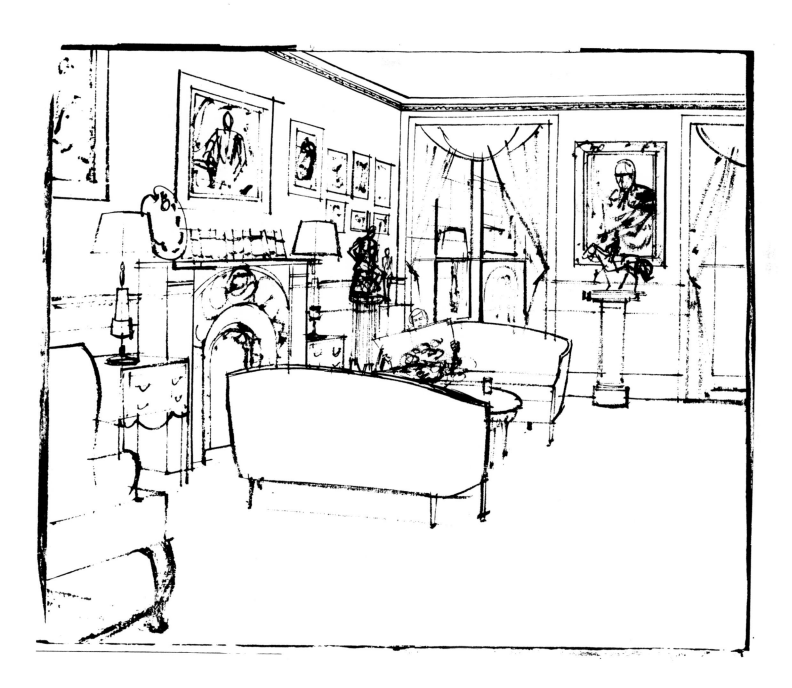

The first step is what I call massing. This is a way of laying in using only two values, one for light and one for shadow. Once the painting is massed in with these two values I have a simplified version of what the painting will look like when completed. To determine which values I use to mass, I look into the shadow area and decide how many basic values it contains—in this case three, middle gray, dark gray and near black. The average value is a dark gray. Later, when refining my values, I adjusted this dark gray going lighter or darker where necessary. The same holds true with my lights. There are about three basic values in the light areas—white, light gray and middle gray—the average value being light gray.

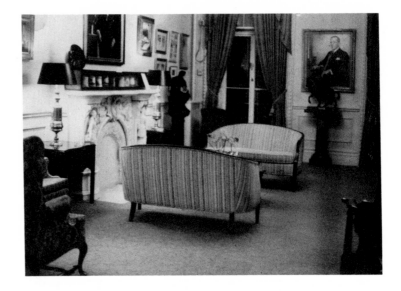

Notice how thinly the paint was applied here. This was done to enable me to see my drawing beneath. The paint will also dry faster allowing me to move quickly to the next stage. Already the effect of the single lamp illuminating the room can be seen. I used a No. 5 bristle brush. The paint was applied thinly striving for a broad poster-like quality with a great deal of simplification.

Once the picture was massed in I began to refine values. Starting with the shadows I painted in the correct values over the dried massed values. By limiting myself to three big shadow values, it was surprising how easy it was to indicate the objects in shadow. I then developed a few areas in the shadow areas; for example, the pictures on the mantle were worked into a little more than other areas. I also went slightly lighter and darker than the basic three values of shadow to model some of the other objects, but I was careful not to develop them too much in case changes were needed later. I was still using the No. 5 flat bristle, painting quickly, working for the overall look and trying to build up everything at one time. The paint was applied more thickly at this point, so when I go back into the shadows for the final rendering, I can work into the wet paint. If I worked too thinly the paint would dry quickly and, the real joy of working in thick, juicy paint would be lost. Actual painting time elapsed was about four hours.

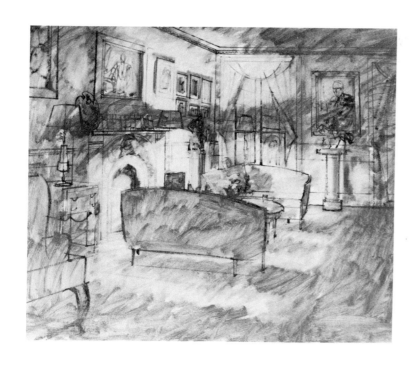

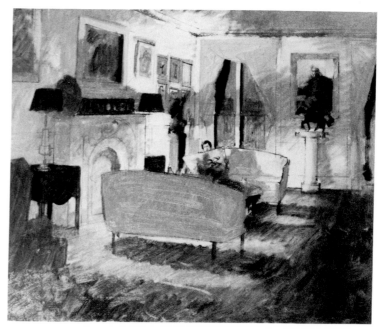

Next I began working into the light areas, painting the true values of the lights on top of the massed values I had previously laid in. White is reserved only for the areas around the lamp. Everything else was progressively darker as it recedes from the light. If I didn't dissipate the values in this manner, the feeling of light in the room would be lost. The only place pure white is used is on the lamp itself. As I mentioned earlier, a room is basically a box and I thought of this as I painted. I also kept in mind the big masses of the objects in the room, for until they were established, I couldn't refine the painting and expect it to be convincing.

The next step was a critical one—developing the half tones. The problem faced here is showing those subtle areas of half light and half shadow without losing the big masses of light and shadow. To do so would turn the whole painting into a jumble of unconnected values. The key to this is the basic light source, the lamp. By keeping this in mind I was able to paint the halftones on the wall and mantle, going darker as they move away from the light but not so dark as to compete with the shadows. While painting these halftones I also started to soften edges where needed. The floor was developed with the paint richly applied so the tones merge and soften as they meet. In painting the soft carpet I used the paint to help describe that softness. Up to now only one or two No. 5 bristle flats have been used. I prefer turpentine sparingly used as my medium. The whole picture was now covered with wet paint.

At this stage a long look was taken to see the painting from a distance and to ask some critical questions. Had I caught the original mood? Were the values right? Was the pattern holding the picture together? A no answer to any of these questions, would require changes. The paint was wet and fairly easy to wipe off for adjustments. I could now safely work on the individual parts of the painting and finish them without losing the overall look of the picture.

Working with a smaller No. 2 Bristle Flat and a small pointed sable for the smallest details, I started to finish the painting part by part. The mantle and pictures on it, the paintings on the walls and the lamps were done first, then the closest sofa, the chair in the foreground and the two windows. The far wall along with the painting, sculpture and stand were

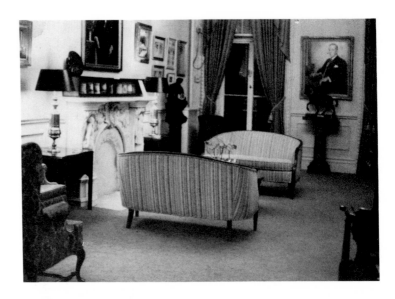

completed next. Occasionally I used a one inch flat sable brush to blend one value into another. The soft tones on the walls and ceiling were done this way as were the parts of the rug where the halftones merged into shadow.

I usually paint the center of interest last. It is evident how I've almost worked in circles, starting with the border of the painting I came in closer and closer to the center of interest. Most of the painting was finished now except for the center of interest around the lamp and figure. Because I wanted the viewer's eye to go there I've saved my strongest contrast for that area. The lamp was finished, gently spilling light onto the relaxed figure reading the paper. I moved the newspaper up to cover part of his face, to show him more engrossed in reading than was apparent in the sketch.

A last look at the painting from a distance made sure no final adjustments were needed. I liked the broad handling but felt a few more edges needed softening and a detail or two were added. I resisted the temptation to do anymore rendering. The overall look of the painting seem successful and more detail would serve no purpose.

156

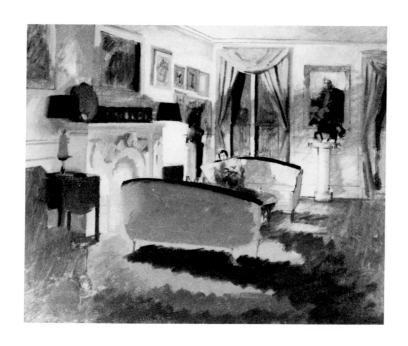

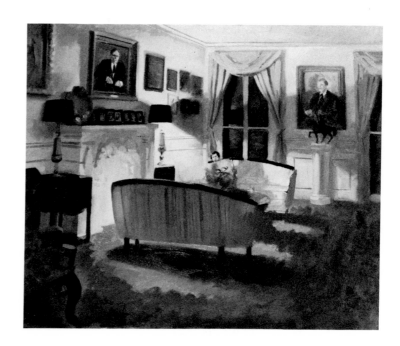

157

The painting is finished. After it dried I gave it a few sprays of retouch varnish to brighten up some of the sunken-in shadow areas. In about six months I'll give it a final coat of picture varnish to protect the surface from dust and dirt.

In writing the text, the whole procedure seemed simple and clear. But thinking back to when I did the painting, there were some trying times. There was one point when I was sure I lost the whole mood and was going to end up with an uninspired pot-boiler. I believed in the idea enough to keep painting, however, and finally, in the last stages, knew I had caught something of the original idea which prompted me to paint "The Sitting Room."

This case history is fairly typical of the paintings I do. Some give me such difficulty that they're put aside for a while and picked up later to be finished. Others are abandoned. And, on a few rare occasions, a painting goes so smoothly it seems nothing can go wrong. Usually, however, it's a give and take battle with occasional good paintings emerging along with a determined effort to make the next painting the best one yet.

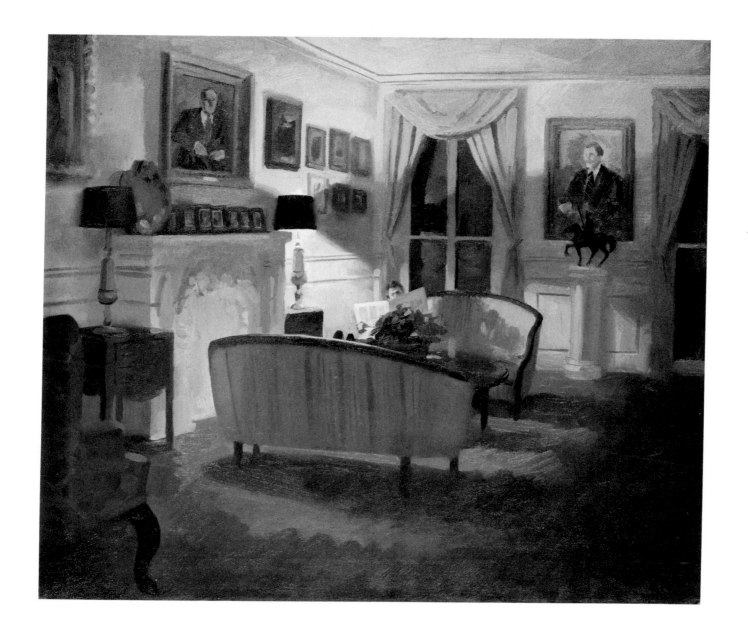

CHAPTER 10
A Gallery of Pictures Painted Indoors

This last chapter contains paintings by various other artists of scenes indoors. In choosing the people represented here, I tried to get as great a variety as possible to show just how many ways there are of approaching the subject.

My first thought was to show interior paintings done by Old Masters, then I decided it would be better to include some contemporary painters along with the Old Masters. Finally, after browsing through some bookstores and seeing just how many books there were on the painters of the past available, and when combining this with the many books and fine reproductions most libraries have, I decided to show contemporary painters only, with the hope that anyone wanting information on the Old Masters had plenty of sources available.

In collecting the paintings from the artists represented here, and looking at the original paintings sitting side by side in my studio, two things occurred: one, how diverse every artist was in his choice of what to paint and how to paint it; secondly, was my way of approaching the subject going to communicate that idea clearly. Seeing all the paintings assured me the idea was a valid one and indeed there is a world of pictures to paint indoors.

I've asked each one to write in his or her own words, about their particular paintings. Most complied. Some dwell on the technique, materials or methods. Others talk about how the painting was conceived and why the subject was chosen. I find all the writings revealing and an insight into the unique way each artist solved the problem.

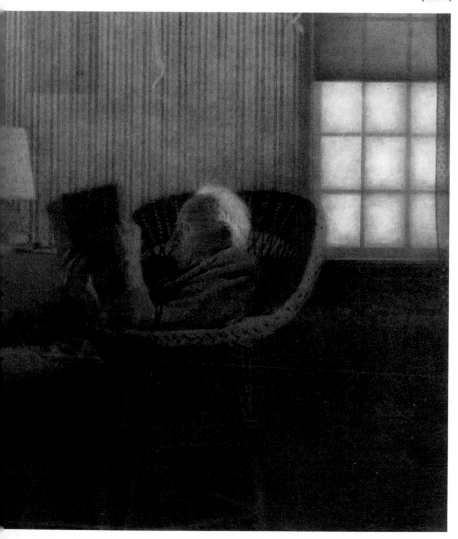

Mark English

The gentleman reading is totally immersed in his book and everything in the picture is designed to convey that mood. Imagine bright patches of sunlight on the floor or strong contrasts of tones on the man's face and hands. In his restraint the artist achieved just the right value arrangement to fit his subject. It is a relaxed picture in low key with a note of dignity.

This painting won a gold medal at the Society of Illustrators 19th Annual Exhibition.

Suzanne Lemieux

This project originated when a group of artists decided to explore their various interpretations of one subject. Our idea was to recreate the feeling of a Victorian interior by arranging a variety of characteristic objects gathered from our attics.

The mood of the interior seemed to vary dramatically according to the lighting. By daytime, the set-up seemed colorful, feminine—almost frivolous! By night, it was mysterious, secretive, shadowy, speaking of a strange, unknown personality as if the presence of an occupant could be felt.

Not to be ignored, however, were the strikingly unusual colors of some of these old objects—the faded lavender of a lavishly embroidered shawl, the harmonious earth colors of a dusty hatbox, the contrasting pure, bright notes of fresh flowers! Therefore, in the final version of "Diviniana", I lightened the key a bit so all those lovely colors wouldn't just disappear into dark grays.

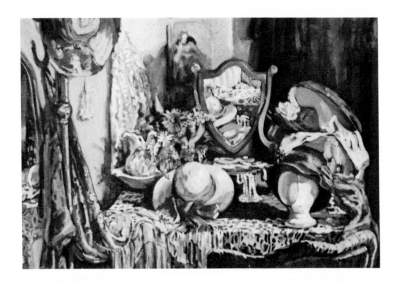

In the daytime, I completed this pastel painting. The color was basically warm and light with accents of intense color.

The painting entitled "Diviniana" was painted in the evening in order to control the lighting. The original concept was the effect of an interior lit by a solitary light bulb—reminiscent of looking into an old shop window at night with forms emerging from shadows and disappearing back into them.

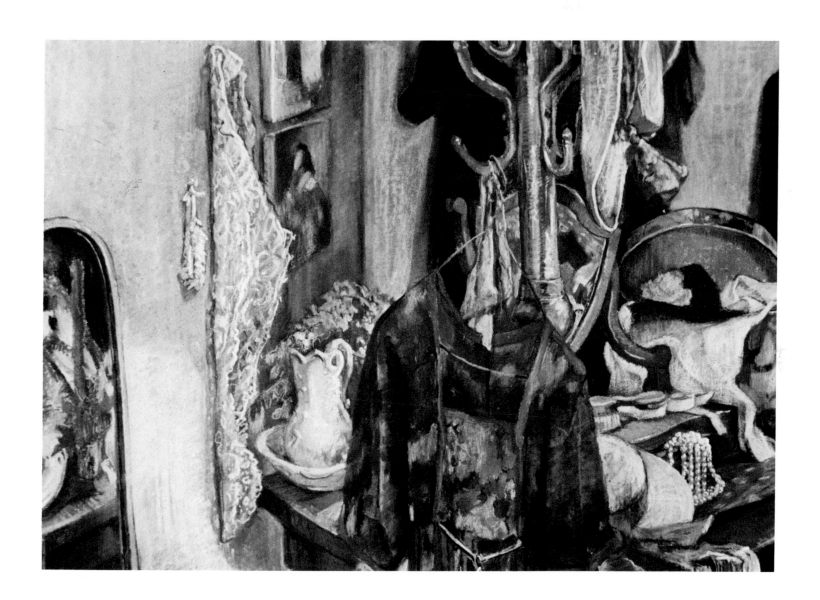

Howard Munce

This painting evolved from having once tacked a discarded peanut bag to my studio wall. It's one of the many such salvaged graphic oddments I like to hang on to.

After seeing it subliminally several times a day for a couple of years, it suddenly demanded to be dealt with.

I immediately went to the market to buy peanuts to fill it. And there, I chanced upon a bin of coconuts. Voila! The odd couple seemed meant for each other!

I was intrigued with their brownness and tanness, their bigness and the smallness, their hardness and softness, and as often happens in my pictorial process, I was beguiled by words. The word in this case was "nuts".

After setting the two side-by-side, I went through the usual letdown of something seeming so good in the mind's eye then becoming a bust when you get down to cases. They proved drab together.

Presently, the thought of the beautiful white interior occurred to me. So I broke the shell and revealed its deep hollow stage. The image came alive!

After deciding to draw the peanut bag out of scale, the rest of the painting evolved out of my personal kind of trial, error and torture. I don't concern myself with light sources because they restrict me from making arbitrary design decisions. That's also my attitude about other real and factual elements. The background and foreground are all invented. In this case, the roundness of the coconut led to the desire for more curves to set up rhythms throughout the picture. They're all arbitrary; I simply put things where I think they'll do good for all the other elements. The many curves oppose the strong straight shaft of the bag. Though I've taken liberties with the printed elephant, I was also careful to keep the character of the original. The same with the type. I sought to make it look like a painted version of a printed word.

I've painted the coconut as precisely as I'm capable of—but my first goal is always design. Since peanuts come in every conceivable shape, I've reshaped them a bit when it seemed the thing to do.

I also invented the background patterns so I could put them where they would *effect* the picture, not merely decorate it.

I would feel hampered if I had hung two pieces of cloth there and been tempted to copy them.

This leads me to a statement by Matisse that I recently read. He said, "Exactitude is not truth—inherent truth should be disengaged from the outward appearance of the object.

It's nice to drop such an important name into the explanation of a small, simple painting, but the master did say it—and I did feel it before I knew he said it.

Christy Gallager

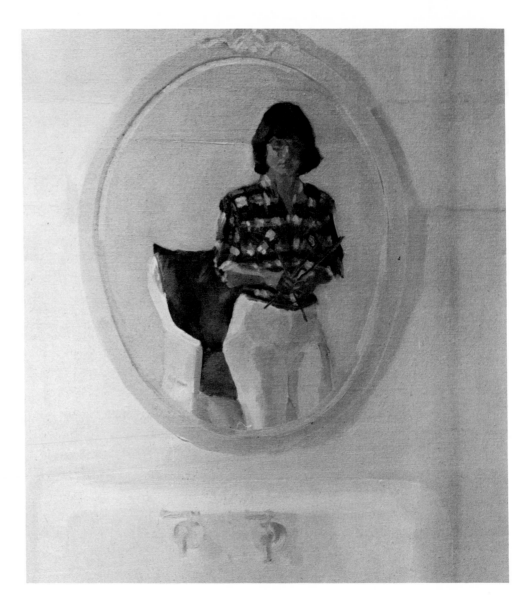

Self Portrait
18x22 Oil on Canvas

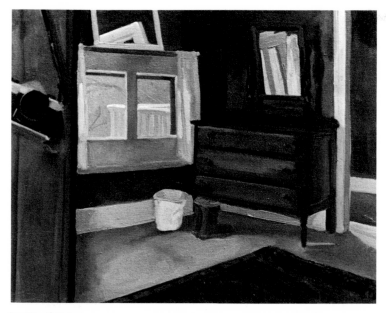

Interior with Bureau
16 × 20 Oil on Canvas

Interior with Table and Chairs
16x19 Oil on Canvas

What a dramatic self-portrait Christy has painted. The square shape of the canvas makes a perfect foil for the round mirror into which we see Christy. Viewing the picture in abstract terms we have a combination of round and square shapes that harmonize with the other elements of the composition.

The two interiors are equally fine compositions. The furniture has been reduced to the simplest basic forms. We know the table is heavy and a person could sit in the chairs. It takes great discipline to edit so much from what you're painting. Christy has succeeded in raising a couple of rather ordinary rooms into a singular artistic statement.

Hal Ashmead

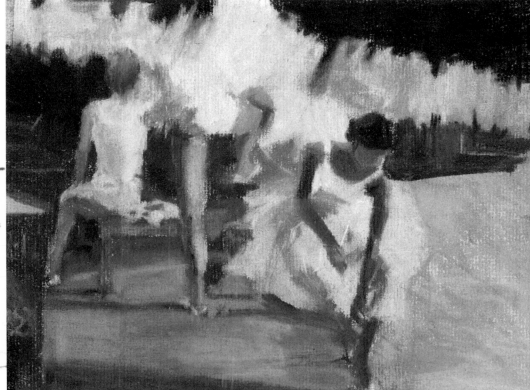

The start of a figure-filled composition can be the most difficult step. What gestures should be used? How big or small should the figures be, in what relation to one another? These questions need to be, at least partially, answered at the start.

Hal Ashmead's background as an illustrator has enabled him to come to grips with problems like these. Using a workmanlike procedure, his picture evolves through logical steps.

The two small pencil roughs reduce everything to basic shapes and a simple value pattern.

The pastel rough is a thorough statement of tones and pattern. Though this little study looks quite finished, it's actually boldly executed with values and pattern knowingly placed indicating much more detail than is actually there.

The pencil study of the seated dancer is added insurance against surprises when painting the final picture.

The finished painting not only incorporates the successful parts of the sketches, but suggests qualities not found in the sketches. The technique is loose and casual, perfectly fitting for the subject.

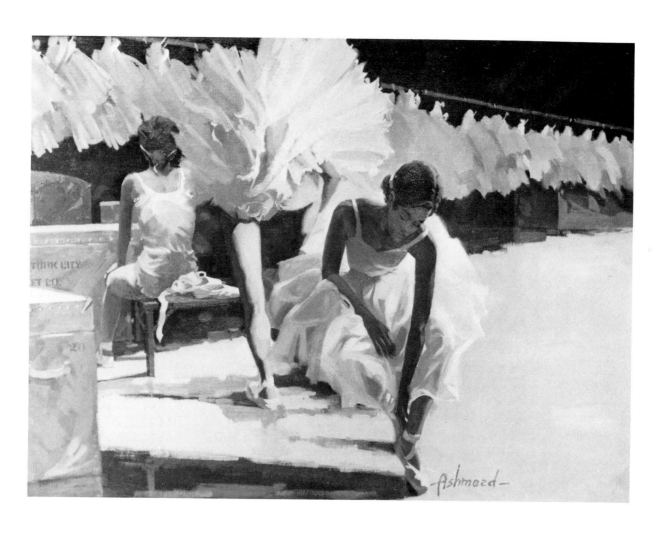

Bob Zappalorti

The objects Bob chose for his painting tell a story. The care with which they're placed also tells a story about the artist. A painter who finds something interesting to paint will all too frequently rush to the studio, hastily set it in front of him and paint, hoping the object will carry all the responsibility for turning the white canvas into a good painting.

Bob Zappalorti's patience in arranging the objects to evoke just the right shade of meaning paid off. The quiet restraint of the technique is perfectly suited for the subject. We could come back again and again to see this painting to see if any of the objects have moved.

Phone Call,
Oil on Panel

Franklin Jones

As a landscape painter I'm always on the lookout for subjects, so when we drive somewhere my sketch pad and camera are always with me. Yet, I seldom find material for a painting this way. Oh, I see some lovely subjects, but without a personal feeling about the place the results are generally not satisfying.

I prefer to paint an area with which I'm familiar—or go someplace and spend a week just walking around becoming acquainted with the material.

Let me give you an example of what I mean: I'm walking in an orchard, viewing the same apple trees for the twentieth time, one afternoon the temperature is in the 90's, the air is deathly still. The foliage-laden branches of one tree hang drooped to the ground as though the trunk is too hot and tired to hold them up. I have the same wilted feeling and feel the weight of those heavy branches. This is what I will try to paint. It's not the tree, but the total episode that excites me.

Having found a subject, a whole new experience begins. Developing it into a painting. I might just describe my procedure of developing "Between Chores," the painting shown here. Admittedly, it was more complex than painting an old apple tree, for in this instance my subject was inside a building where hundreds of people passed during the day.

I frequently visit Old Sturbridge Village, a working museum of rural New England life in the early 1800's. One of my favorite buildings is the old farm house, perhaps because of the delicious aromas that rise from the ovens. On a crisp, gray November afternoon, while enjoying a piece of hot ginger-bread, I saw a young fellow who works on the farm, come in and sit by the kitchen window, his long yellow scarf draped loosely around his neck. There was my stimulus for a painting of the room.

I got my sketchpad, tucked myself back in a corner of the room so as to be as inconspicuous as possible, and made drawings of the scene. Then I asked the young man if he would pose for some photographs. He obliged and when I finished and we were standing outside, I looked up at the sky, sniffed the air, saying "Smells like snow." He looked at me in disbelief. "You can smell snow?" "Why, sure!" Then he told me he had never seen snow. This was his first trip to this part of the country and they never had snow where he lived.

I finished my sketching, returned home, and spent many hours making composition studies. Finally, satisfied with the

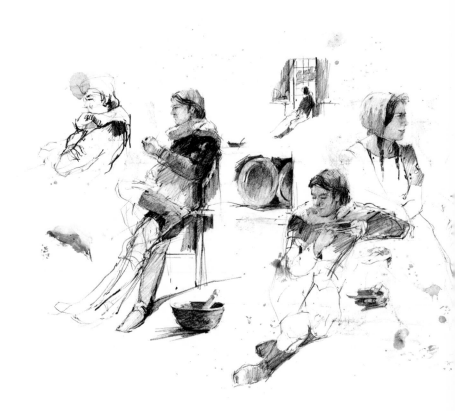

A FINAL WORD

"Art after all is but an extension of language to the expression of sensations too subtle for words."

Robert Henri

ACKNOWLEDGEMENTS

A lot of people were helpful in the writing of this book and I'd like to say thanks.

To the kids at the Paier School of Art whose young questioning minds provided much of the stimulus to develop a clear method in showing what picture making is all about.

To Howard Munce for his caring attitude, drawings, tips, wit and all-around savvy.

To Christy Gallager a painter of quality whose ideas were inspiring.

To Walt Reed who believed in me enough to get the idea going.

To Bill Fletcher and Fritz Henning who kept it going with their support, understanding and know-how.

To Deborah Dutko-Sovek for not only her drawing, but whose belief in the book got me back into it when work almost stopped.

To: Bert Dodson
 Mark English
 Suzanne Lemieux
 Hal Ashmead
 Bob Zappalorti
 and Franklin Jones
 who unselfishly let me use their drawings and paintings as examples.

To Martha Runner who typed the manuscript.

To Dave Robbins and Fritz Henning who watched over the production.

And to Paige Gillis, Mary Boulton and Evelyn Welch for welcoming me into their homes to paint a lot of the pictures shown in the book.

174

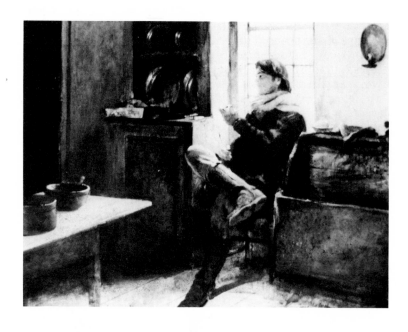

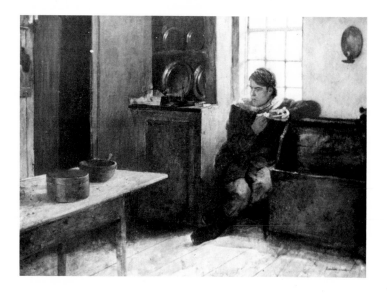

design, I went back to the village to make small watercolor studies of the room. To my surprise, I found the museum had completely rearranged the furniture in the kitchen. Preferring the original arrangement, I had to make studies of the individual pieces, to be reorganized back home.

In my studio, using my studies and photographs of the figure, an acrylic painting was started. The idea of showing snow outside the window was a kind tribute to my model. Three more trips to the village, for reference, and the painting was complete. I call it "The Smell of Ginger."

Shortly after publishing the work in one of my books, the pose of the figure bothered me, so I put the painting away for a couple of years. Finally, I did a watercolor painting of the same subject but with a new figure arrangement. It worked better so the figure in the acrylic was painted out and replaced by the new pose. I re-titled it "Between Chores."

Sometimes I'm asked if it bothers me to sell a work that I am fond of. No, for the whole experience provides me with lasting memories of a place and a time. I remember the smell of gingerbread and woodsmoke, pleasant conversations with the lad in the yellow scarf, the warmth of the kitchen on a crisp November day with the smell of snow in the air.